THE
Archive Photographs
SERIES

WALTHAMSTOW

FELLOWSHIP IS LIFE

The Arms
of the
Borough of Walthamstow.

THE
Archive Photographs
SERIES

WALTHAMSTOW

Compiled by
Keith Romig and Peter Lawrence

TEMPUS

First published 1996
Reprinted with corrections 1998
Copyright © Keith Romig and Peter Lawrence, 1996

Tempus Publishing Limited
The Mill, Brimscombe Port,
Stroud, Gloucestershire, GL5 2QG

ISBN 0 7524 0359 1

Typesetting and origination by
Tempus Publishing Limited
Printed in Great Britain by
Midway Clark Printing, Wiltshire

Contents

Acknowledgements

Vestry House Museum
Jim Connor
Stations U.K.

Introduction

Within the urban sprawl of today's Walthamstow, the original late Saxon settlements can still be identified. Four clearings were made in the great Forest of Essex on the fertile eastern slopes of the Lea valley at Higham Hill, Hale End, Wood Street and on Church Hill.

The Domesday record of 1086 shows that there were two feudal manors in Walthamstow: Wilcumstou (Walthamstow) and Hecham (Higham). Both were later subdivided and the manors of Low Hall and the Rectory formed out of Walthamstow and Salisbury Hall formed from Higham. The origin of the small manor of Mark (Mark House) is obscure.

The ancient parish was bounded by Chingford to the north, Wanstead and Woodford to the east and the River Lea to the west, although much of the original course of the river is now within the reservoirs. To the south, the boundaries with Leyton were curious. One boundary started in the forest, just east of Forest School, and ran in almost a straight line for three miles to the Lea. Part of that boundary ran along today's Boundary Road and the line of trees behind the ice rink in Lea Bridge Road. A gate that separates Leyton's ancient lammas lands from Walthamstow's equally ancient marshes is still there. More curious still was a three-mile strip of land about a quarter of a mile from that boundary, in Leyton, known as the Walthamstow Slip. This strip, which varied in width from fifty to one hundred yards started at the Eagle Pond, Snaresbrook, went directly west and ran parallel with Capworth Street to the River Lea. There is no definite reason for this detached strip of Walthamstow parish but it was handed back to Leyton in 1873.

Until the mid-nineteenth century Walthamstow was still a country parish, noted for its woods, farms and views over the marshes towards London. Much of the farmland was set aside for grass. Wealthy farmers known as 'graziers' made a handsome living just fattening cattle for the London markets. Other land was used for market gardening, cereals and hop growing. Grapevines were grown in Sir William Batten's garden in the late seventeenth century and, according to Samuel Pepys, his friend and colleague at the Navy Board, the vintage he bottled was acclaimed by his guests to be as good as any foreign wine. Sir William Batten's house was in Marsh Street, a street with several fine houses occupied by wealthy merchants and crown servants. The same street is today's High Street.

As with neighbouring Leyton, Wanstead and Woodford, Walthamstow became a popular place for the wealthy to establish their country houses, as it was so convenient for London. Many famous names are associated with Walthamstow: George Monoux (d. 1544), merchant

draper and Lord Mayor of London, Admiral Sir William Penn (d. 1670), Commissioner of the Navy, Sir Robert Wigram (d. 1830), Chairman of the East India Docks, and of course William Morris (d. 1896) who was born in the parish and lived at the 'Water House' in what has become Lloyd Park. That house and several other fine eighteenth-century buildings remain to serve as a reminder of Walthamstow's more rural and affluent past.

Although the railway had a station at Lea Bridge by 1840, a branch line to Shernhall Street with other stations at St James Street and Hoe Street was not completed until 1870. By 1873 the line was open to Chingford with Wood Street station replacing Shernhall Street and Hale End (Highams Park from 1894) added to the service. The Midland Railway's stations at Black Horse Road and Edinburgh Road were opened in 1894.

The coming of the railway had its usual effect. As early as 1861 the wealthy were selling their estates for development and moving further out. Cheap working men's fares stimulated development. Most of the earlier suburban streets were built between Forest Road and the Leyton border. Higham Hill was developed from 1876 and thirty-eight street names were put up in 1878. Mr T.C.T. Warner began the Warner Estates in the 1880s and the Shernhall Street/Wood Street area was sold off in the 1890s.

The economy grew with the population. Eight licenced premises in 1828 had grown to twenty-nine by 1863. The ancient coppermill site was converted to a pumping station in 1860 to supply fresh water to the new houses. By the 1880s the market was established in Marsh Street and therefore the Local Board changed the name to High Street in 1882. By 1897 there were 96 factories and workshops registered. Companies that supplied the nation with chemicals, electrical and scientific components came to Walthamstow, as did the motor vehicle and film industries. There were film studios at Whipps Cross, Hoe Street and Wood Street from 1910. Apparently the light in Walthamstow was clear, therefore assisting the technical limitations of the early cameras; also the land was cheap. But Hollywood caught up in the end and the last studio in Walthamstow closed in 1933. In the forty years between 1871 and 1911 the population rose from 11,092 to 124,580. People from other parts of London and the home counties came to settle in Walthamstow, attracted by cheap new houses to rent, jobs and easy commuting to the City.

Among those newcomers were my father's family who moved into a Warner's maisonette in Theydon Street, off Markhouse Road, and my mother's family who rented a brand new house in Gloucester Road. After the First World War my grandfather started his own coal merchants business with a friend; therefore considering my family's strong connections with Walthamstow, I hope the reader will indulge my inserting some of my family archives into this book. The majority of the illustrations in this book originate from the authors' collections of photographs, postcards and antiquarian publications. The contents concentrate on well known main road locations then go on to highlight residential streets, occupations, buildings, public transport, churches, schools, and public houses.

In an everchanging world publications such as this are becoming increasingly important, not only for nostalgic enjoyment but as a vital educational resource.

Peter Lawrence, D.L.Hist (Ldn),
a member of Walthamstow Historical Society

One
Highways

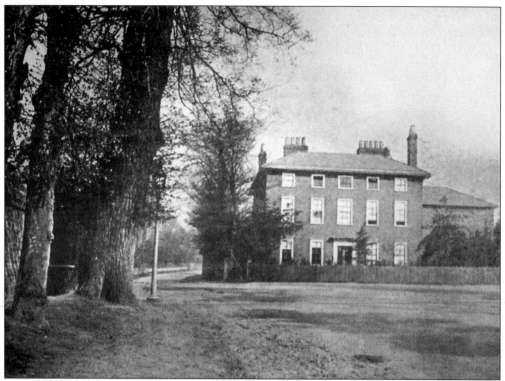

Looking north along Hoe Street at the junction of Grove Road on the right c. 1890. The Red House was built early in the nineteenth century and the grounds extended up to Pembroke Road. It was demolished in 1963 and flats now stand on the site.

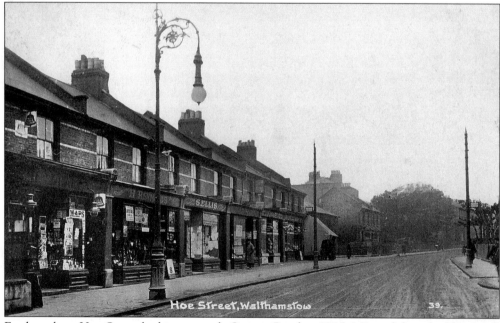

Further along Hoe Street looking towards Queens Road c. 1915. Most of these buildings still survive, and flats now occupy the site of the clump of trees in the distance.

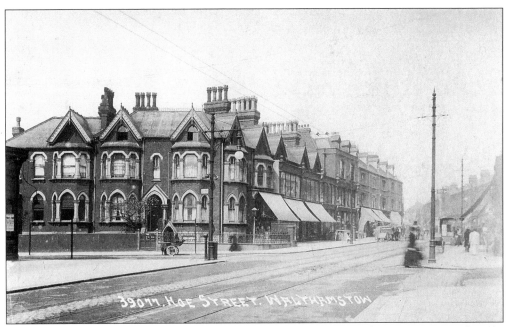

Hoe Street at the corner of Albert Road c. 1916. The house on the corner was a doctor's surgery. The ornate chimney pots still survive.

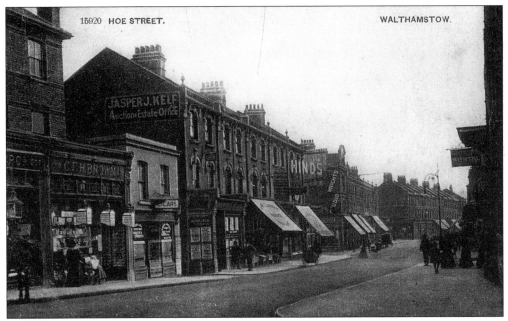

Hoe Street looking south from the station c. 1905. The narrow entrance between the shops on the left led into Baltic Yard, used as a garage by an independent bus operator in the 1920s, and latterly by a coach company until demolished in the 1980s in connection with the road developments at Walthamstow Central.

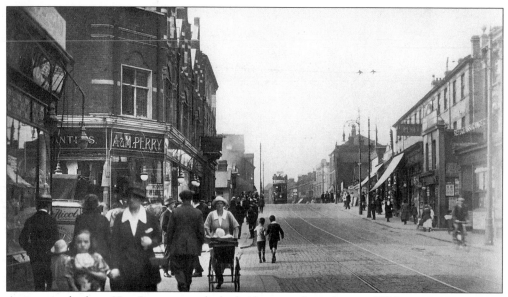

A view north along Hoe Street towards the bridge over the railway c. 1920.

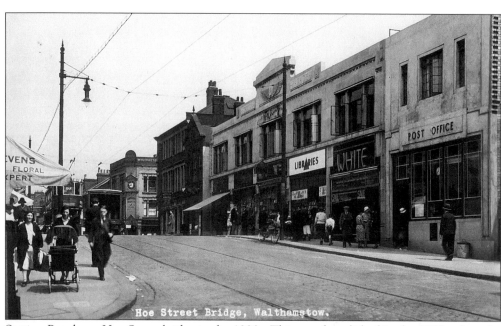

Station Parade on Hoe Street bridge in the 1930s. This was demolished in the 1980s when the roadway was widened and an additional bridge was built over the railway in connection with the new bus station built in Selbourne Park.

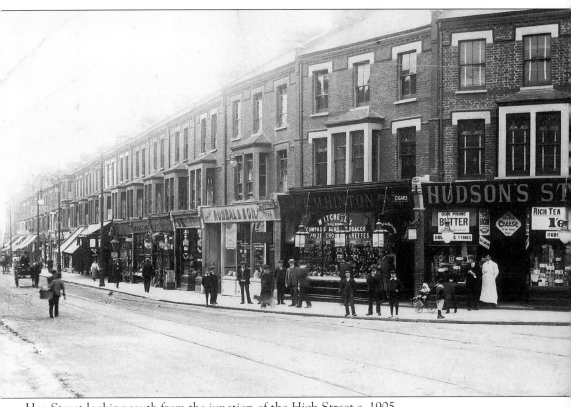

Hoe Street looking south from the junction of the High Street c. 1905.

An advert from 1916 for Saville's music shop. Saville's was about halfway along the row of shops in the picture above.

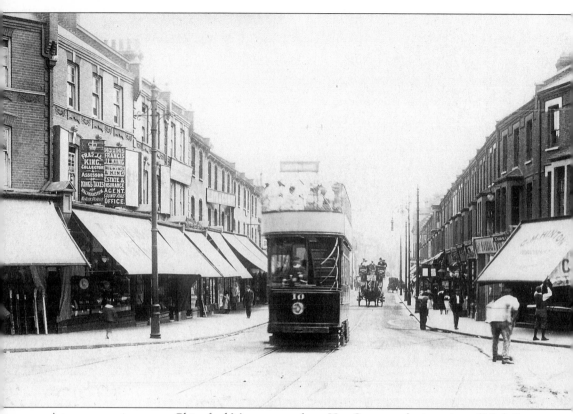

A tramcar on its way to Chingford Mount runs along Hoe Street at the junction of High Street and Church Hill c. 1906. Following close behind is a horse bus. On the left are the premises of Francis J.L. King, Collector and Assessor of King's taxes for Walthamstow. Note the crossing sweeper on the right.

An advert on the back of a tram ticket for J. James-Davies store.

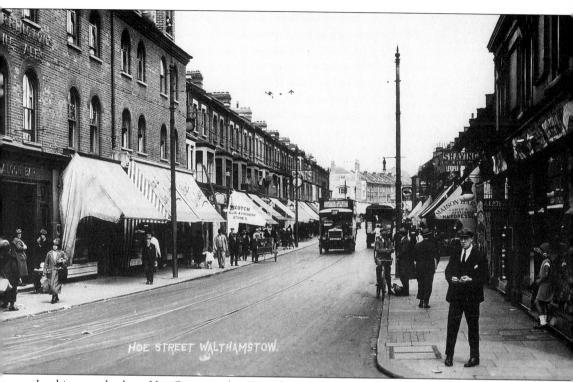

Looking north along Hoe Street in the 1920s from the corner of St Mary Road with a London General Omnibus Company open-top bus on route 38A to Victoria.

A 1d L.G.O.C. bus ticket issued on route 38 c. 1930.

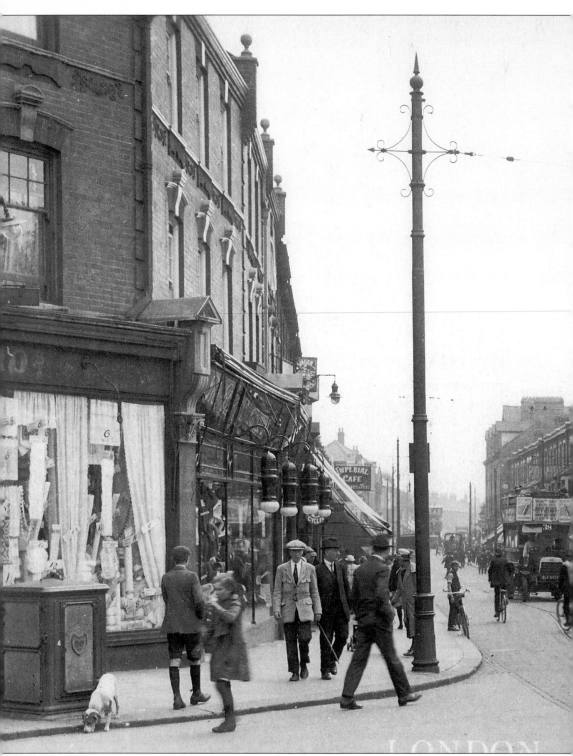

Hoe Street in the 1920s from the corner of Church Hill with a 38 bus nearing the end of its journey from Victoria.

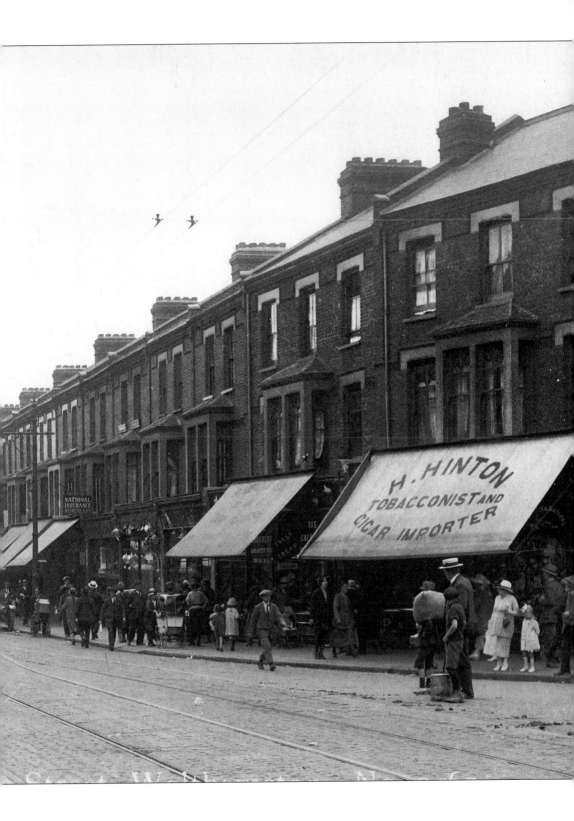

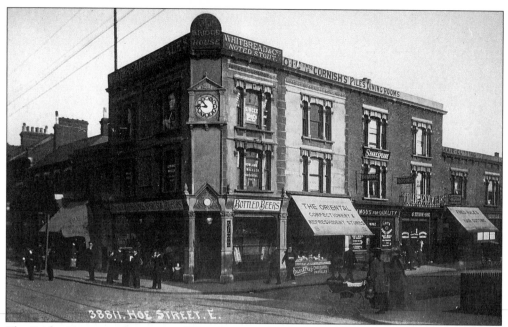

The Bridge House on the corner of Hoe Street and St Mary Road c. 1910. Pile's Dining Rooms are offering, "A cut from the joint and two vegetables for 6d." (2½p).

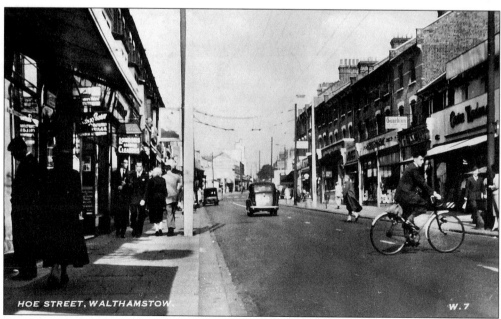

Hoe Street in the 1950s with the Granada Cinema in the distance.

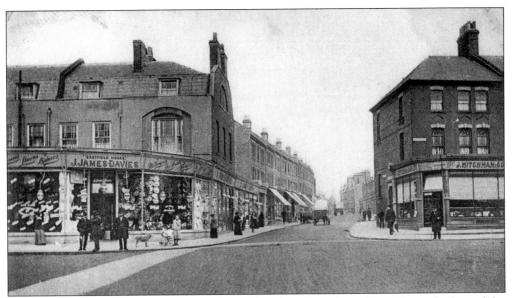

Hoe Street with High Street to the left and Church Hill to the right in the early days of the century. Eastfield House on the left was built in the seventeenth century and was demolished in 1938.

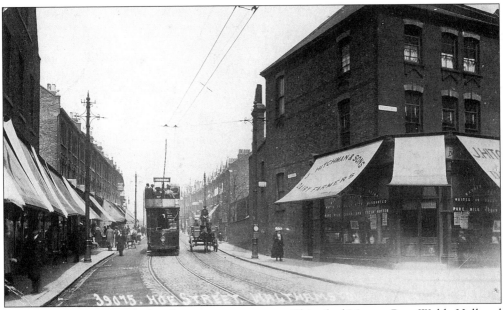

A similar viewpoint c. 1915 with a tram on its way to Chingford Mount. Ross Wylde Hall and shops now stand on the site of the building on the right.

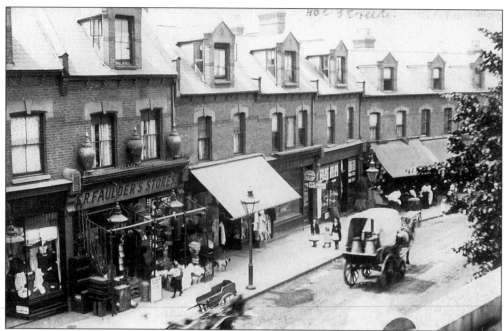

A horse-drawn milk-cart heads down Hoe Street towards the Bell Corner in the early days of the century.

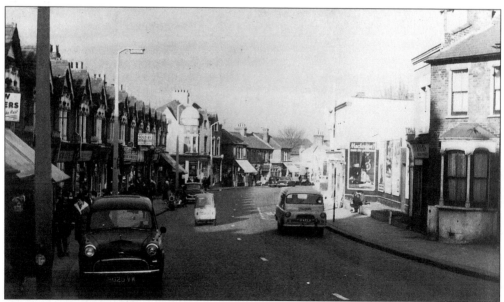

Hoe Street looking north towards the Bell Corner in the 1970s.

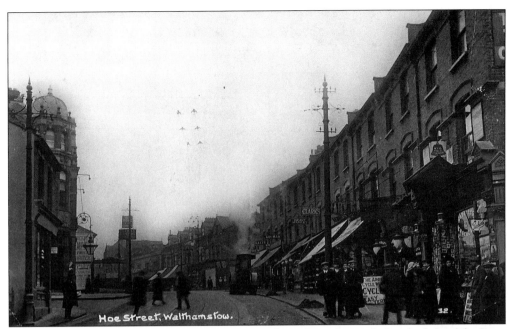

Hoe Street looking south with a steam roller trundling along the road. On the left is The Rose and Crown public house.

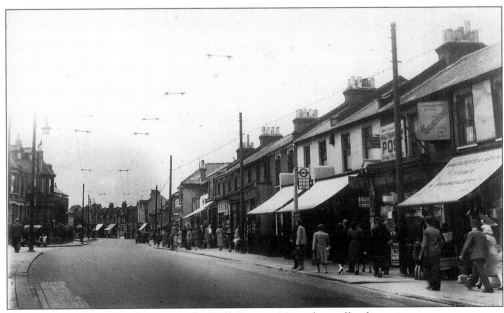

Hoe Street in the 1950s from near the Bell Corner. Note the trolley bus wires.

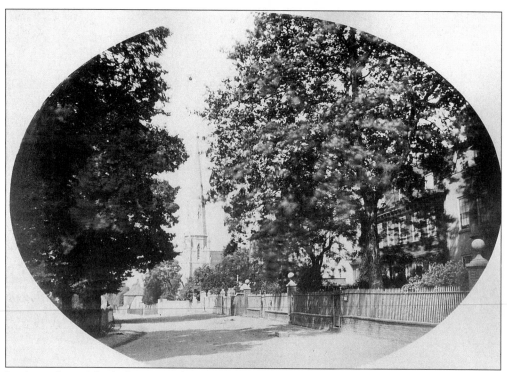

Looking down Marsh Street in the 1870s with Marsh Street Congregational church visible through the trees. On the right are some of the fine Georgian houses which once stood in this road. Marsh Street was renamed High Street in 1882.

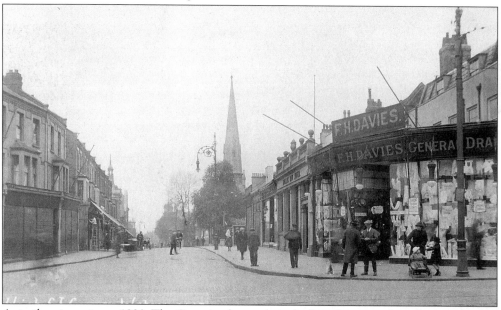

A similar viewpoint c. 1920. The Georgian houses have had single-storey shops built in front of them. The spire of the church was damaged by a flying bomb in 1944 which killed twenty-two people. It was demolished in 1954 and the church was knocked down in 1965. The post office now stands on the site of F.H. Davies.

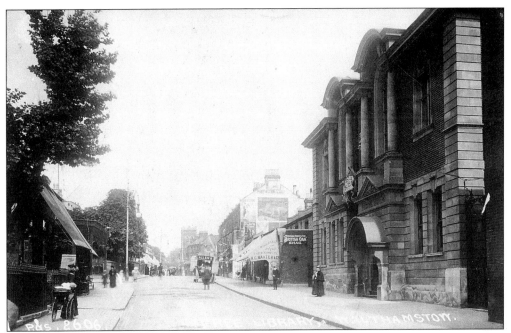

Looking up High Street c. 1911, with the public library on the right. The library was opened in 1909.

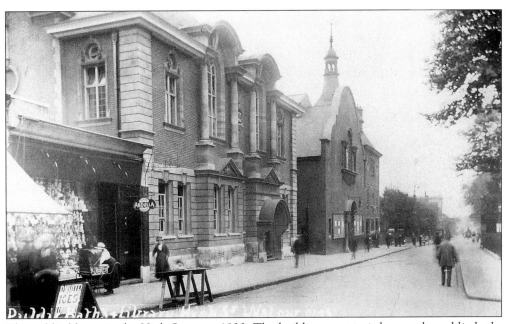

The public library in the High Street c. 1920. The building next to it houses the public baths which were opened in 1900. They were enlarged in 1923 and demolished in 1968.

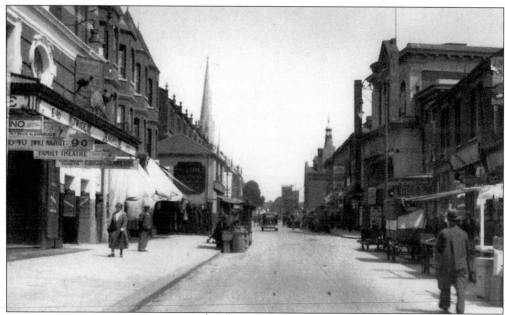

High Street with the entrance to the Palace Theatre on the left. On the right is the Carlton Cinema which opened in 1913 and closed in 1964.

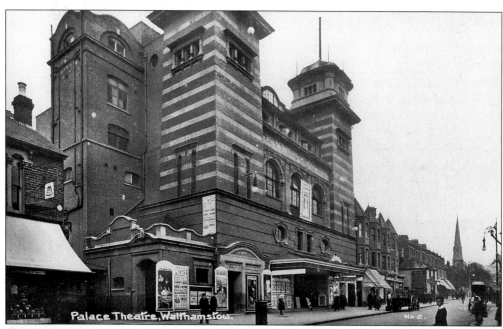

The Palace Theatre in the High Street. It was opened on 28 December 1903 and was Walthamstow's only music hall. The building was demolished in 1960.

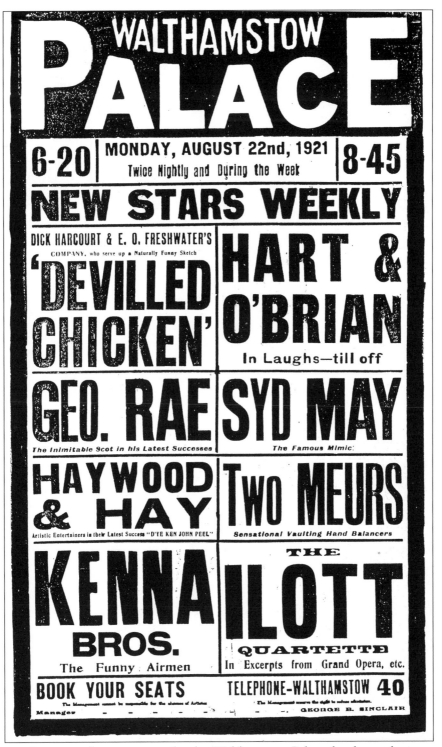

A poster advertising the programme for the Walthamstow Palace for the week commencing August 22 1921.

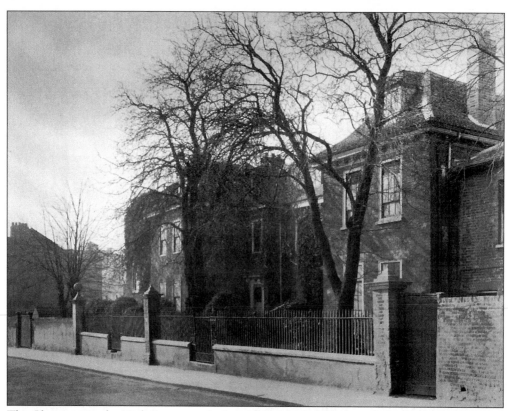

The Chestnuts in the High Street was built c. 1700 on a half H-shaped plan. Latterly known as the Vintry Works of Messrs Gillard, it was demolished in 1932.

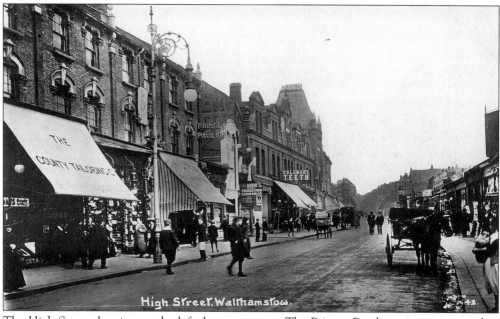

The High Street showing on the left the entrance to The Princes Pavilion cinema, opened in 1909 and closed in 1930.

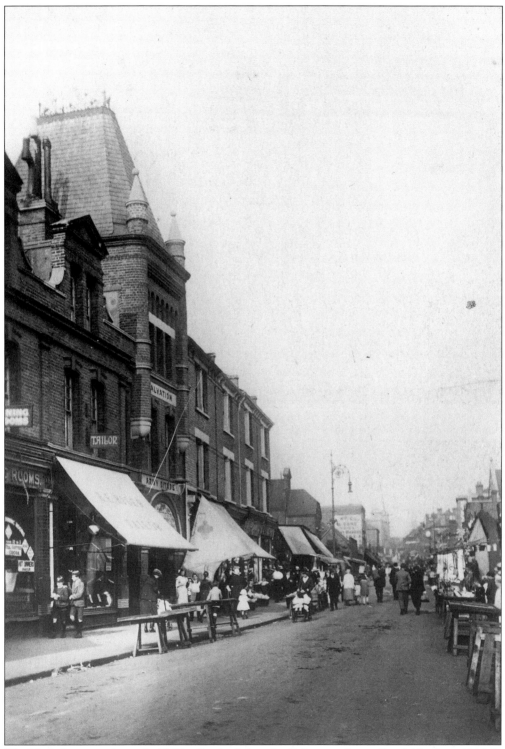

The High Street in the early 1920s. On the left is the Salvation Army Citadel built in 1892. It closed in 1958 and the premises still survive as a shop. Note the trestle tables in the road.

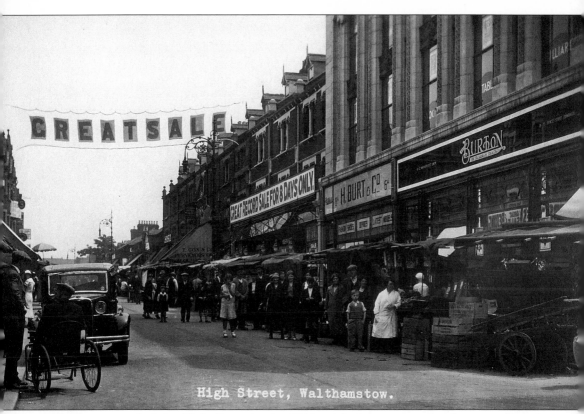

High Street, Walthamstow.

The bottom end of the High Street in the 1940s with shoppers pausing from searching for bargains at the 'Great Sale' to have their photo taken.

An advert from the back of a trolley-bus ticket for Lidstone's Stores.

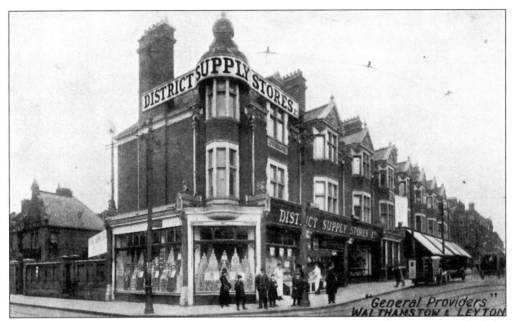

The District Supply Stores at the bottom of the High Street c. 1915. This parade was built by Warners.

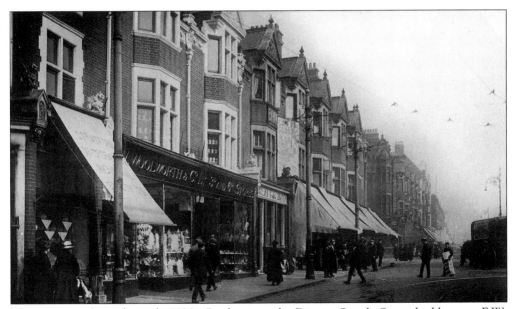

The same parade in the early 1920s. By this time the District Supply Stores had become F.W. Woolworth & Co. Ltd 3d and 6d Stores.

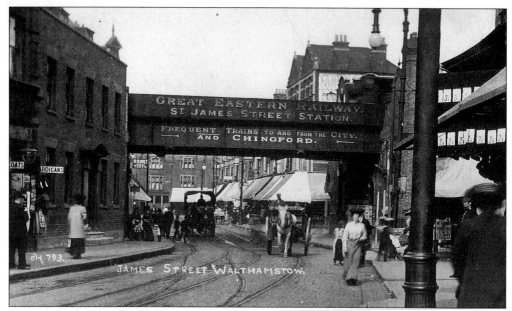

St James Street showing the railway bridge over the road by the station c. 1906.

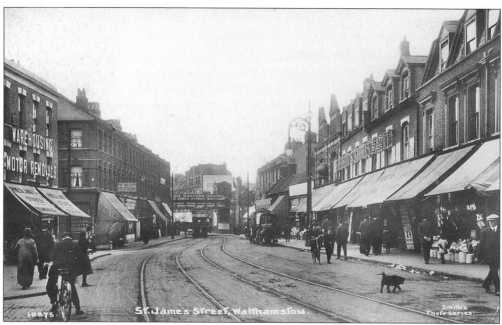

St James Street c. 1914.

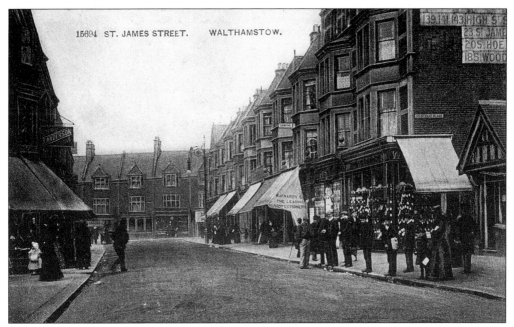

St James Street looking towards the High Street from the railway bridge in the early days of the century.

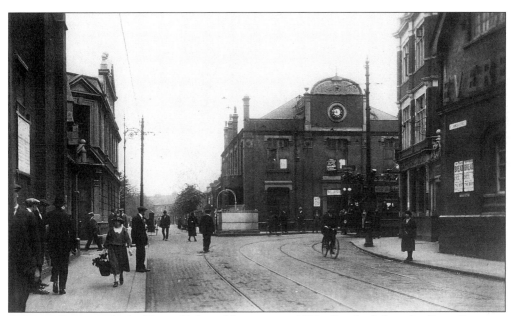

St James Street with the Essex Club and Institute c. 1922. On the left is the Essex Brewery. Only the buildings on the right are still standing, and a roundabout is now on the site of the institute.

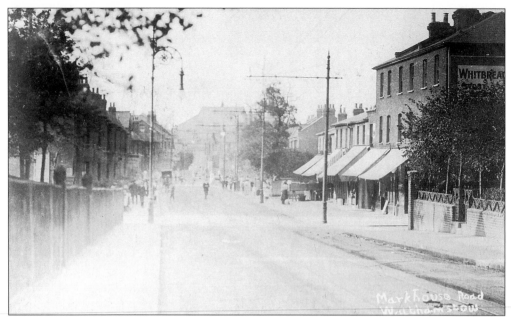

Looking north along Markhouse Road from near Boundary Road c. 1906 with the roof of the Lighthouse Mission in the distance. All the buildings on the right have gone, replaced by modern flats, and further along stands Kelmscott Leisure Centre.

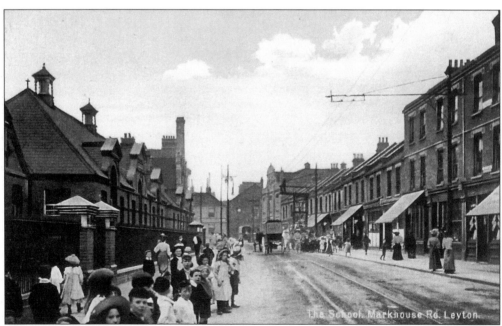

The school in Markhouse Road c. 1910. It was demolished in 1996.

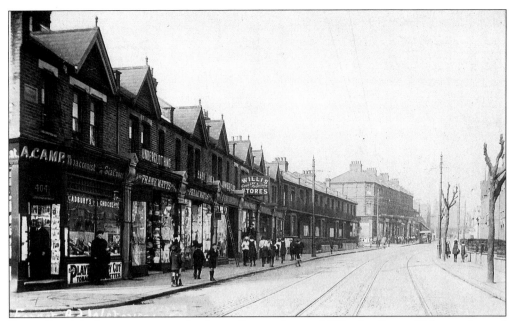

Forest Road looking west towards the police station c. 1920. A. Camp, Tobacconist and Stationer, is no longer standing but all the other buildings still survive.

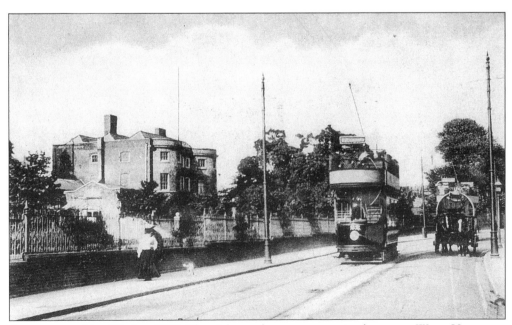

A tram passes Lloyd Park c. 1910. The eighteenth-century mansion known as Water House was the home of William Morris.

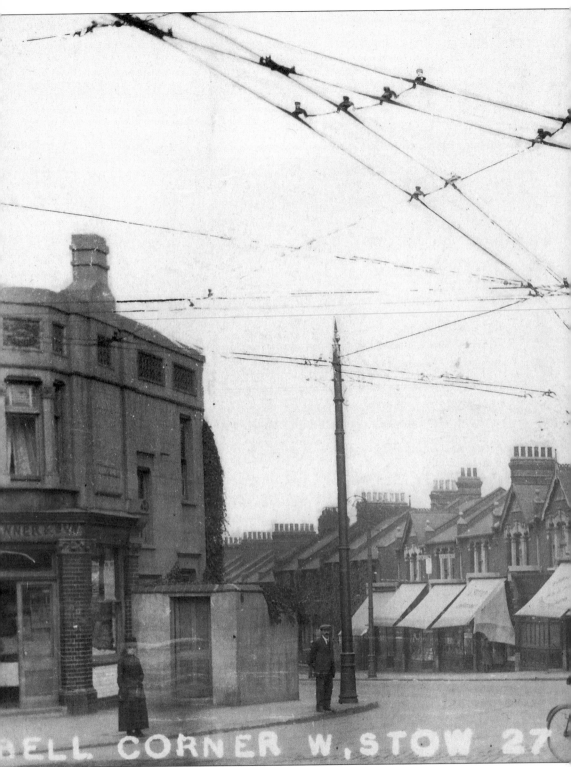

An open-top tram on its way to the Bakers Arms waits at the Bell Corner c. 1920.

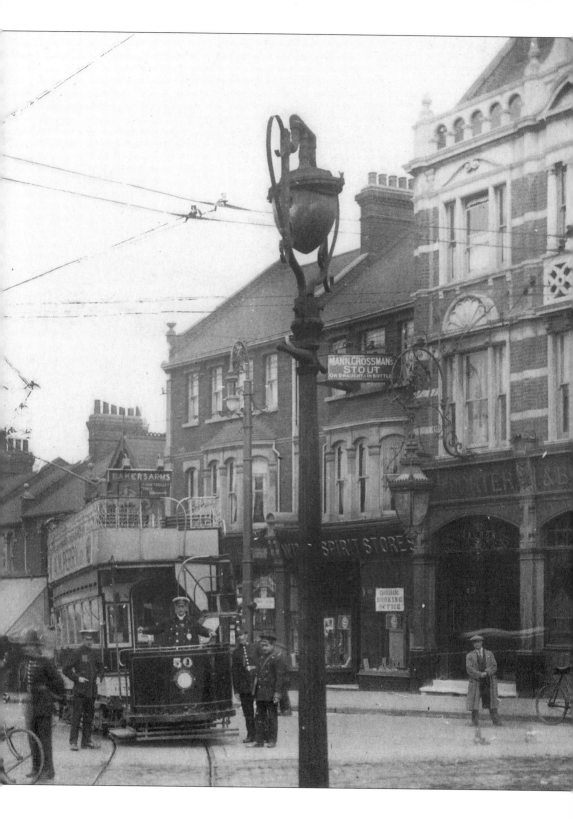

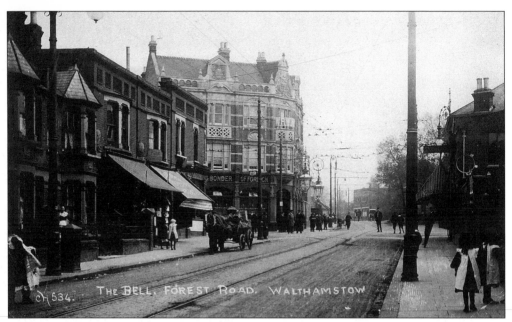

A view east along Forest Road towards The Bell public house c. 1907.

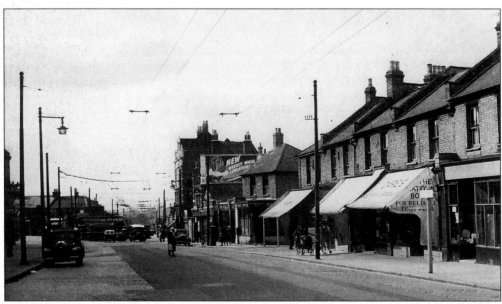

The Bell public house from the east in the 1950s. A trolley bus crosses the junction of Hoe Street and Forest Road and heads into Chingford Road.

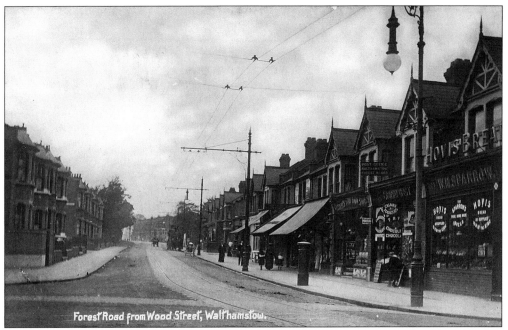

Looking west along Forest Road from the corner of Wood Street c. 1910. The houses on the left are now the site of St David's Court.

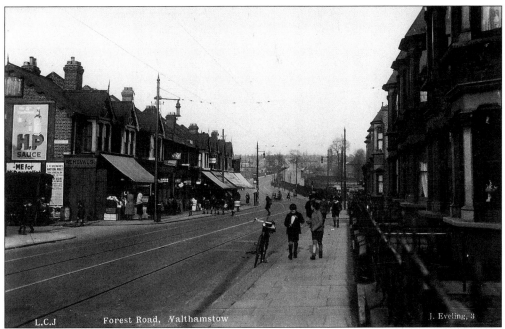

The reverse of the previous picture. Looking down Forest Road towards the junction of Wood Street in 1935 as children walk home from school. The empty space in the middle distance is the site of Wood Street library, opened in 1950.

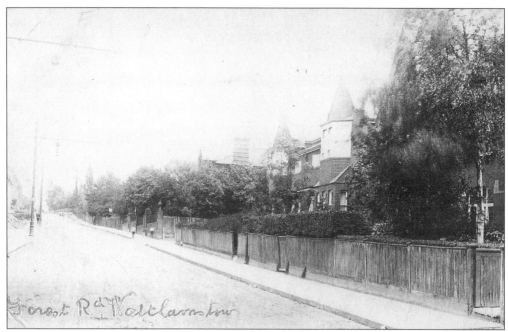

Forest Rd Walthamstow

The view up Forest Road from the corner of Hale End Road, with Fyfield Road on the right c. 1907. Flats now stand on the site of these houses and this part of Fyfield Road is now called Winsbeach Road.

Wadham Road c. 1925, just before the construction of the first North Circular Road. The chapel on the left is still standing at the end of Fulbourne Road.

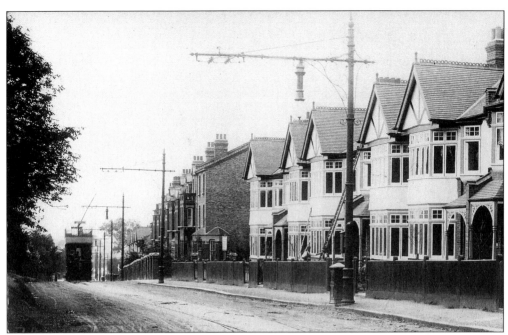

Looking down Forest Road from near the Waterworks. The finishing touches are being put to the houses on the right, between Hillcrest Road and Becontree Avenue.

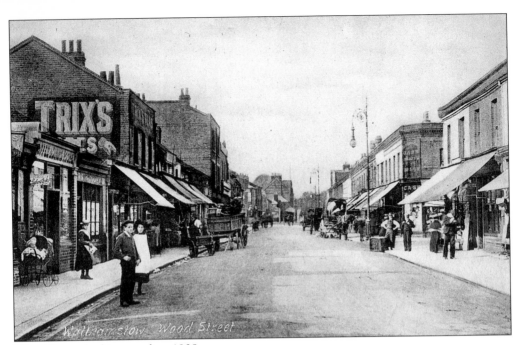

Wood Street looking north c. 1908.

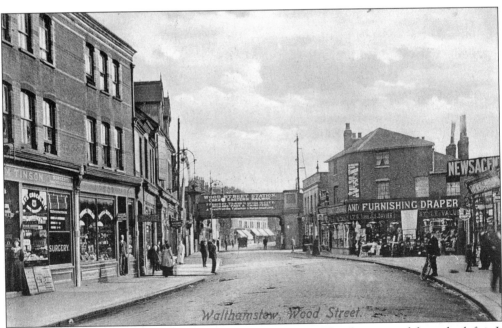

Wood Street with the railway bridge by the station c. 1909. The shop second from the left is J. Pegrum, Bakers. See page 66.

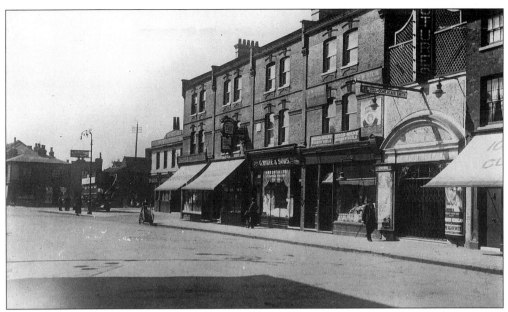

Wood Street c. 1925. On the right is the Crown Picture Palace. This cinema was originally opened in 1912 as the Penny Picture Theatre Co. It was lately called the New Crown and closed in 1950. It is now the site of Wood Street Market.

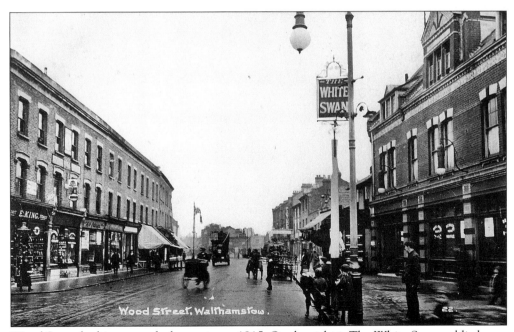

Wood Street looking towards the station c. 1915. On the right is The White Swan public house which was built in 1887.

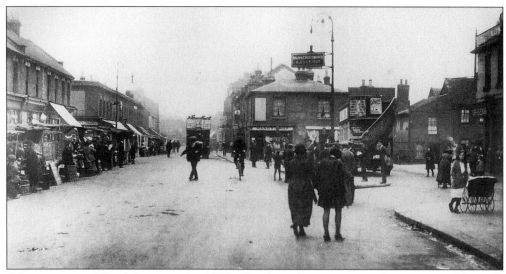

A busy scene in Wood Street in the 1920s. On the right an open-top bus on route 35 stands outside the Duke's Head public house. Note the stalls in the road on the left.

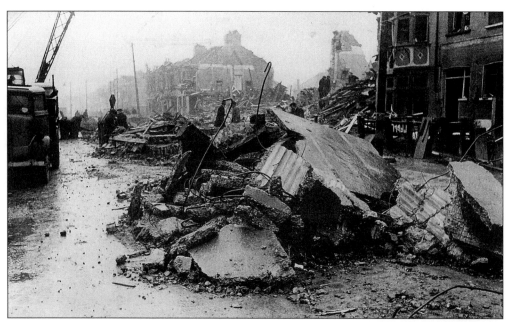

In February 1945 a V2 rocket landed in Chingford Road near Nelson Road, and demolished a surface shelter in which eight people were killed. Eight more were killed in surrounding houses.

Two
Byways

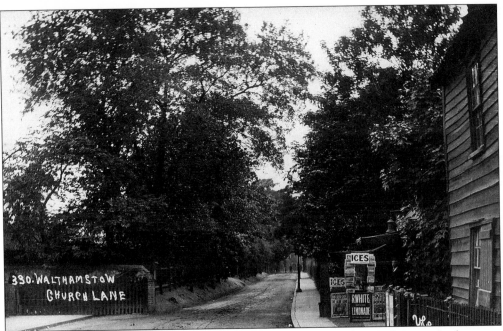

Two views of old houses in Church Lane near the junction with Shernhall Street. In the upper picture a newspaper poster refers to 'Titanic Heroes'.

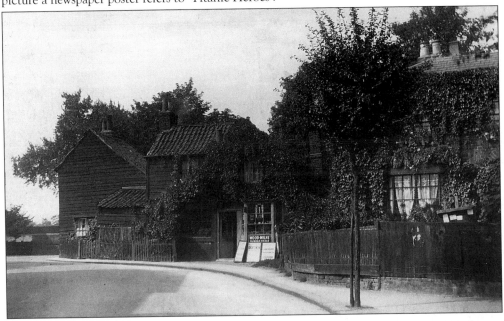

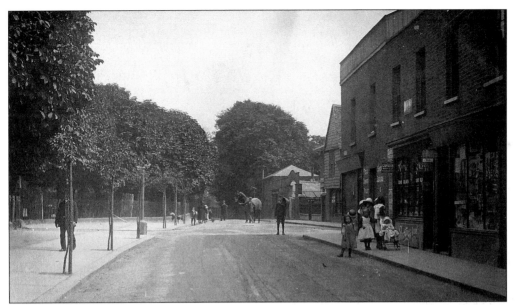

Church End, with St Mary's churchyard on the left and the junction with Orford Road on the right.

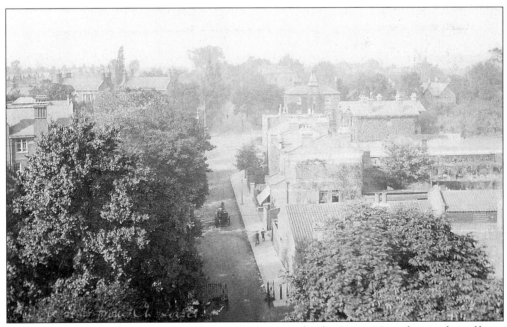

Looking north from the tower of St Mary's church towards The Drive. Note the number of large houses.

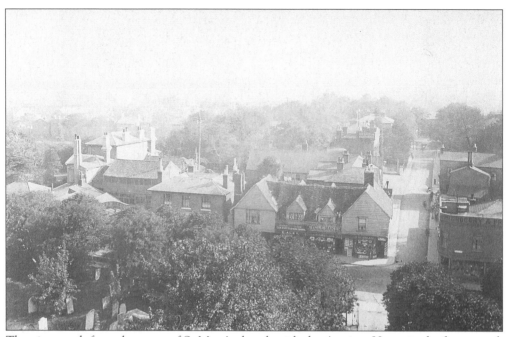

The view south from the tower of St Mary's church with the Ancient House in the foreground.

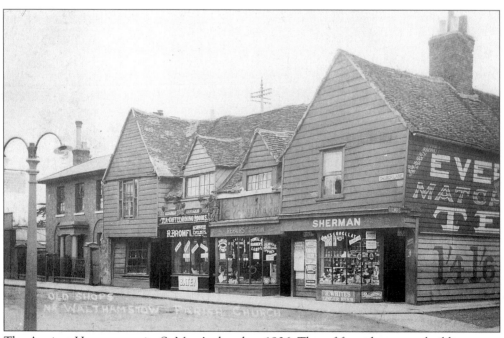

The Ancient House, opposite St Mary's church c. 1906. These fifteenth-century buildings were restored in 1934. The house to the left with the pillared doorway was built in 1830.

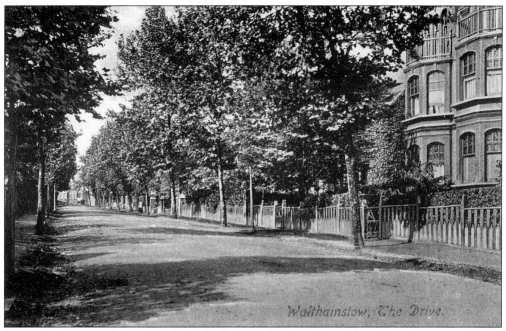

The Drive c. 1914, showing on the right the typical large houses which once stood in this area. Following bombing in the Second World War, flats are now standing here.

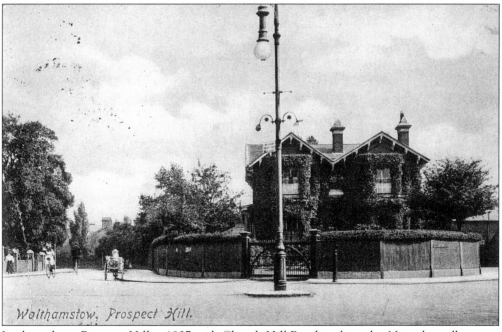

Looking down Prospect Hill c. 1907 with Church Hill Road to the right. Note the milk cart in the road.

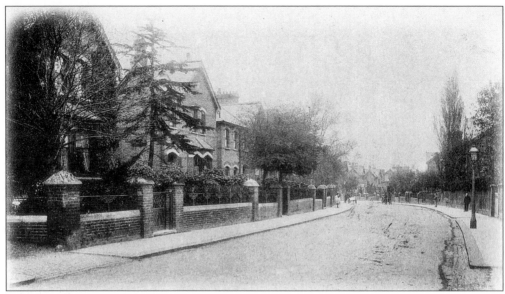

Two views of Prospect Hill c. 1907. The houses on the left suffered from the effects of bombing in the Second World War and flats were built on the site in the 1950s.

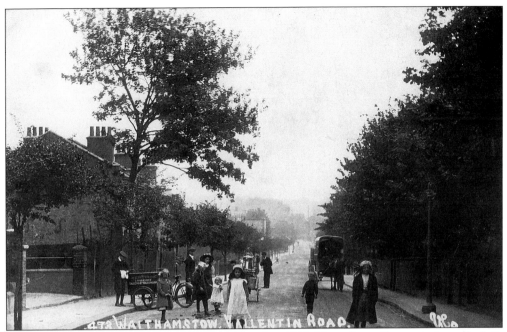

Children pose for their picture in Vallentin Road c. 1910. Note the milk cart and, on the left, the laundryman's delivery bicycle.

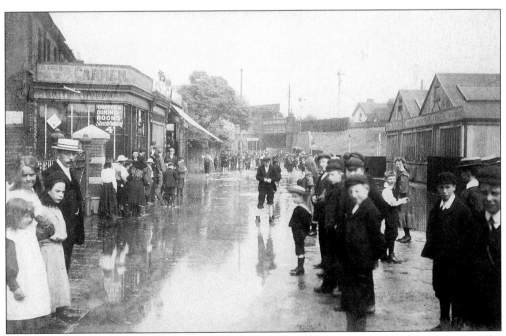

Crowds come out to see the flood in Vallentin Road near the junction with Wood Street. The cafe on the left is offering Steak Pudding for 4d (slightly more that 1½p).

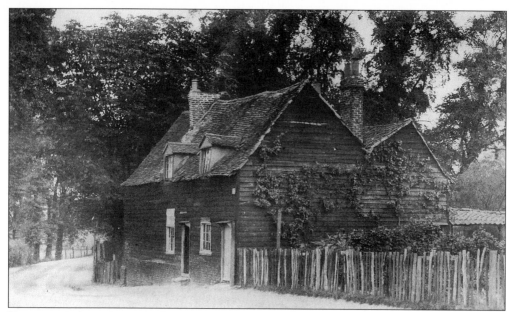

Known as Bakers Cottages, these ancient timber-framed buildings stood in Blackhorse Lane. This view is looking towards Billet Road c. 1895.

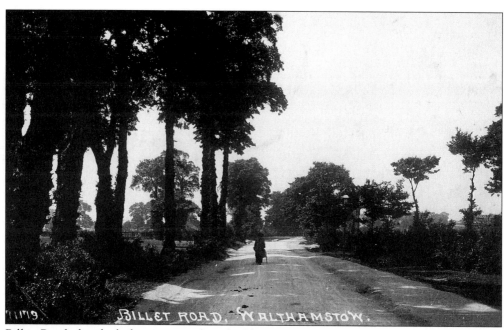

Billet Road shortly before any modern buildings were erected. A notice on the right is advertising land for sale.

50

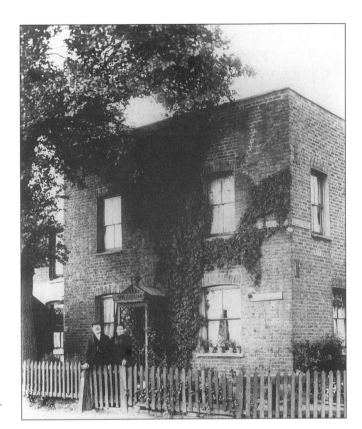

Two elderly Walthamstow residents stand at the gate of their house on the corner of Billet Road and Folly Lane c. 1900.

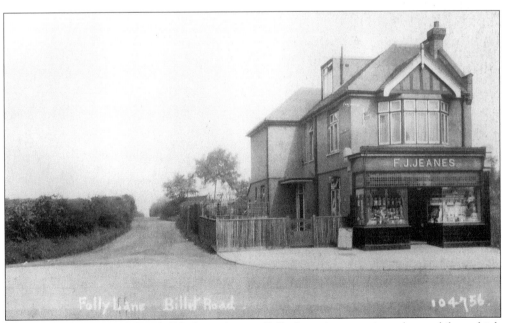

The same corner c. 1925 with F.J. Jeanes' store. Folly Lane is an ancient thoroughfare which connected Walthamstow to Chingford at Hall Lane.

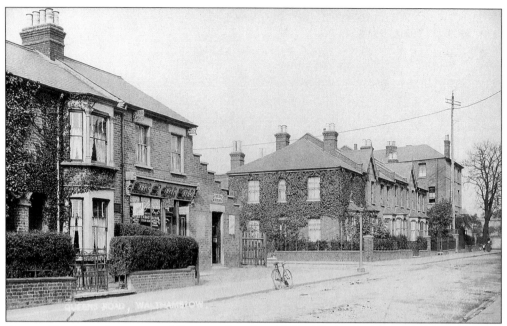

Queens Road, at the corner of Beatrice Road c. 1908. All the buildings are still standing, although the cycle shop has now gained an extension to the corner of the road.

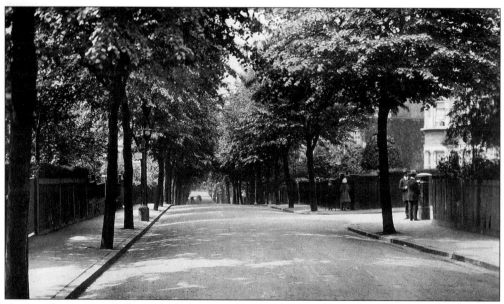

A view along a very leafy Upper Walthamstow Road in the early 1920s.

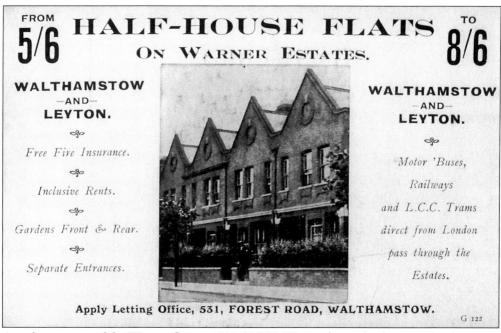

An advertising card for Warner flats c. 1912. T.C.T. Warner began his housing developments in the 1880s, and the Warner Estate Co. continued to build until c. 1930.

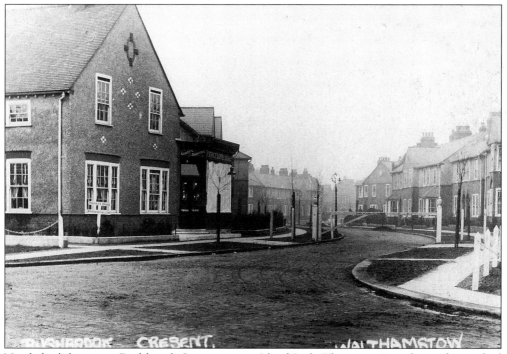

Newly built houses in Rushbrook Crescent, near Lloyd Park. The gate across the road is marked 'Town Planning Estate', and to the left is a 'Private Road' notice.

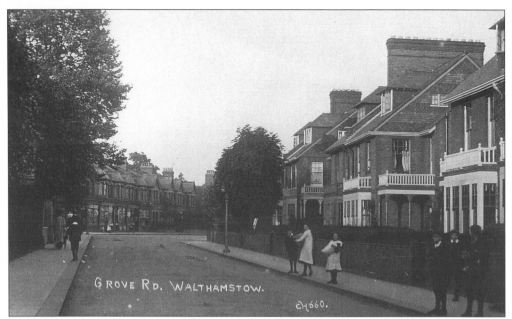

Grove Road looking towards the junction with Beulah Road c. 1910.

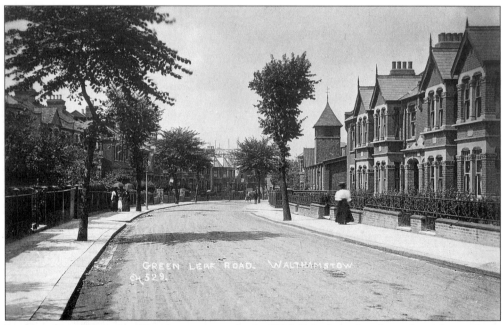

Looking down Green Leaf Road on a sunny day in 1906. St Luke's church on the right was built in 1902. In the distance the Adult Education Centre is under construction and the roof is nearly complete.

Orford Road from Hoe Street c. 1907. The large house in the distance was demolished when the Baptist church was built on the site in 1914.

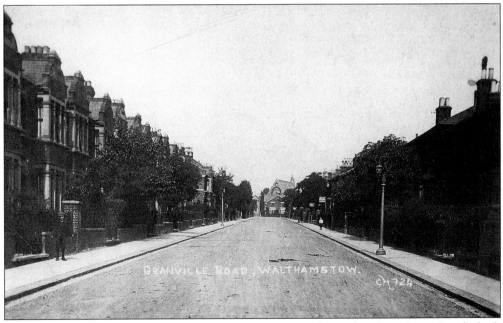

Granville Road c. 1906. In the distance can be seen St Stephen's church in Grove Road which was pulled down in 1969.

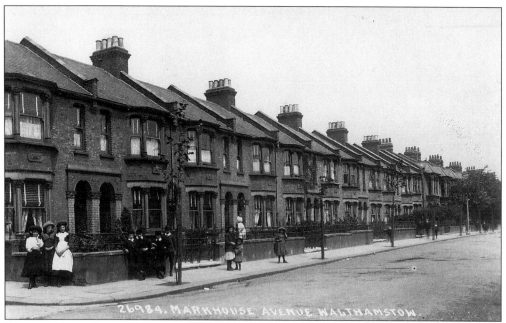

A sunny day in Markhouse Avenue c. 1909 and the photographer has all the children's attention.

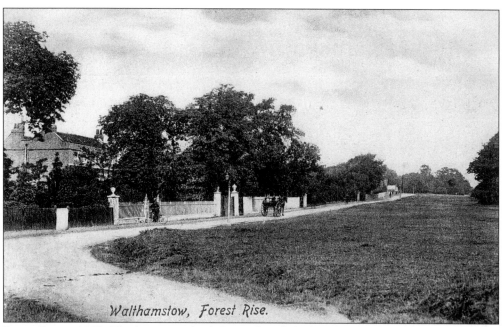

Forest Rise c. 1905. The house on the left was demolished, with others, to make way for The Risings.

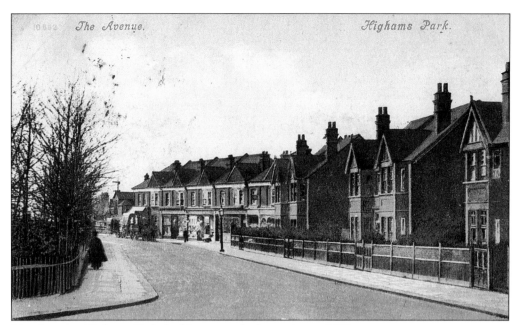

The Avenue, Highams Park, looking towards the station c. 1906.

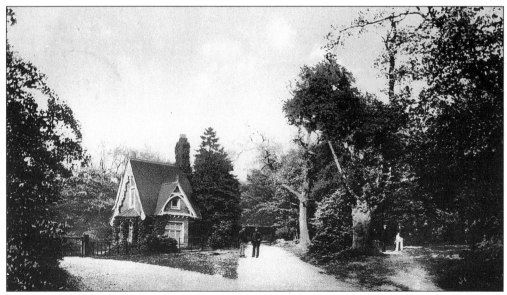

A lodge to the White House. The track in the foreground is the bridlepath near the bottom of Oak Hill. The lodge is still there but was enlarged around 1990.

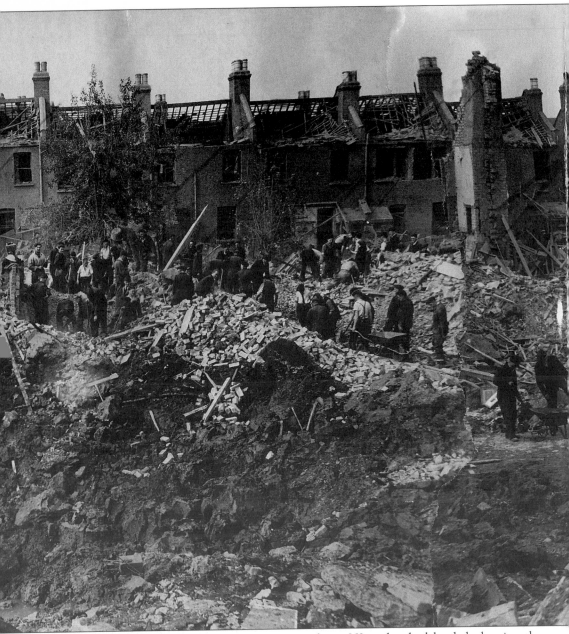

The scene in Farnon Avenue, September 1944, after a V2 rocket had landed, showing the extensive damage caused.

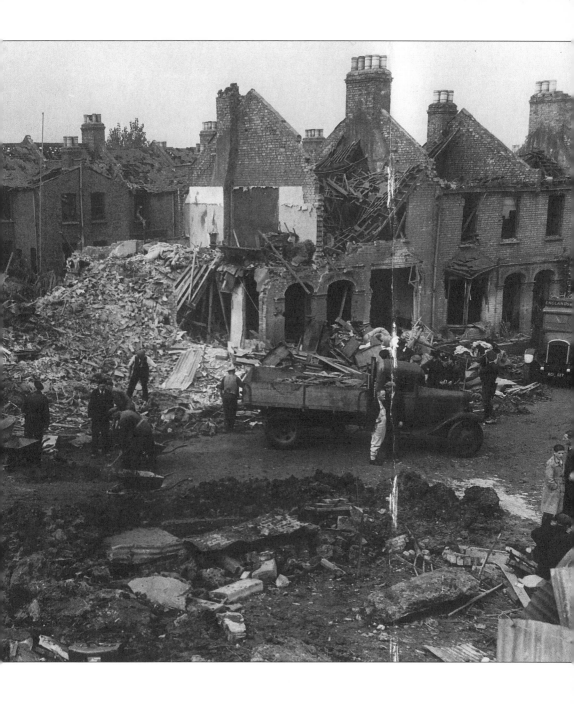

GLOUCESTER ROAD
CHILDREN'S VICTORY PARTY
WALTHAMSTOW, E.17
Saturday, June 23rd, 1945

PROGRAMME

2.30 p.m.—3.30 p.m.
SPORTS
Many Grand Prizes

3.30 p.m.—4.0 p.m.
FANCY DRESS PARADE
6 Valuable Prizes

4.0 p.m.—5.0 p.m.
T E A

5.0 p.m.—5.30 p.m.
MUSIC AND GAMES

5.30 p.m.—9.0 p.m.
GRAND CONCERT
and
PRIZE DISTRIBUTION

Carnival Hats, Novelties, etc. provided

The Official Children's Party will terminate at **9 p.m.,** and Parents are kindly requested to note that until stated time it is a

CHILDREN'S PARTY

From 9 p.m. Adults are requested to join in and Sing, Dance and Enjoy Themselves.

DANCE BAND IN ATTENDANCE

To make this, our Children's Party, a day that they may well remember, please give the Committee your kind co-operation.

A handbill advertising the Children's Victory Party in Gloucester Road on 23 June 1945.

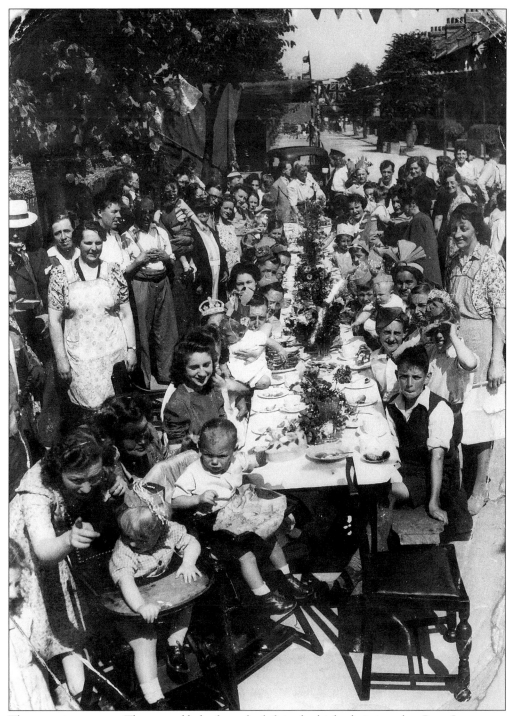

The party in progress. The second baby from the left in the high-chair is author Peter Lawrence, aged 20 months.

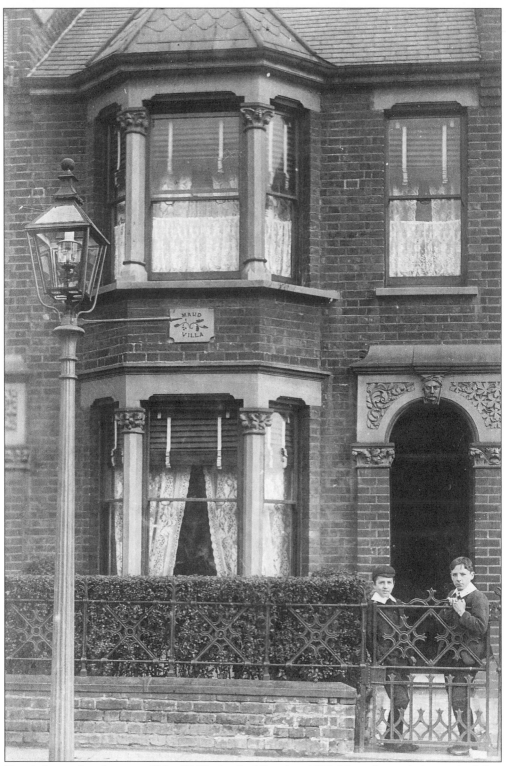

Two lads stand at the gate of No. 27 Chelmsford Road in 1908. Note the gas light on the left.

Three
At Work

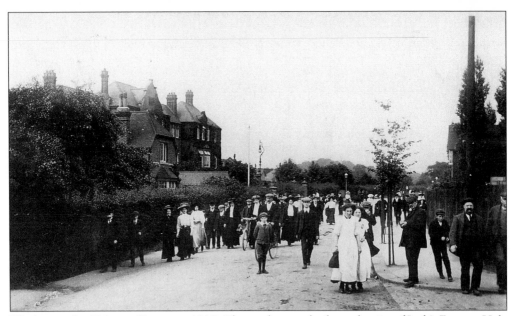

Workers at the Xylonite Factory c. 1910. The works were built on the site of Jack's Farm at Hale End in 1897.

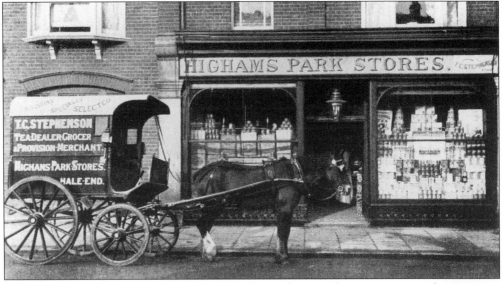

T.E. Stephenson's delivery cart stands outside the Highams Park Stores opposite the station in The Avenue c. 1914.

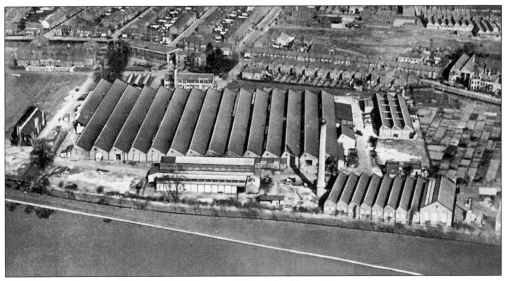

A 1930s aerial view of the Achille Serre works in Blackhorse Lane.

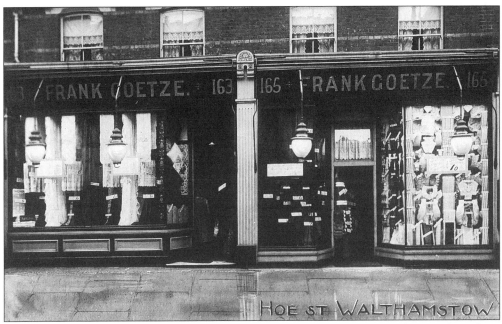

The shop-front of Frank Goetze's business at 163-165 Hoe Street. The window on the right is advertising a special sale of ladies' underwear.

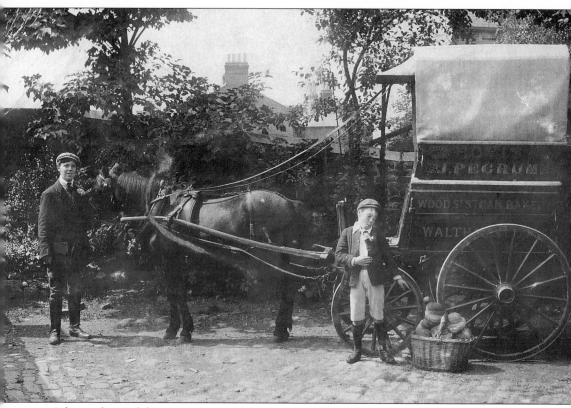

A horse-drawn delivery cart owned by J. Pegrum, Wood Street Steam Bakery. A deliveryman and his young assistant prepare for their round. Note the loaves piled up in the basket on the ground.

An advertisement for J. Pegrum in 1916.

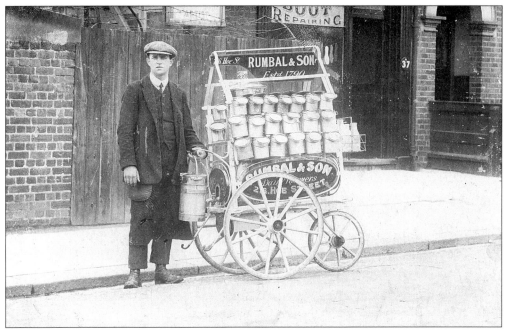

A milk roundsman with his handcart from Rumbal & Son, Dairy Farmer at 216 Hoe Street c. 1908.

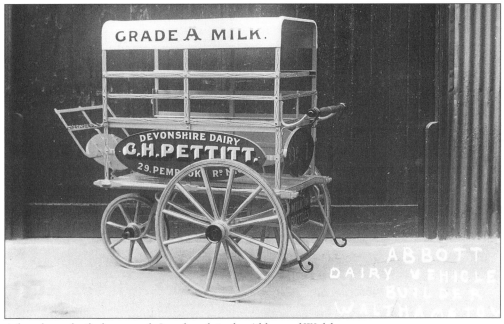

A hand-cart built for a north London dairy by Abbott of Walthamstow.

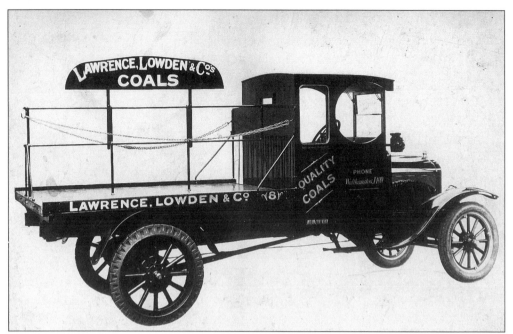

Lawrence, Lowden's first petrol lorry in 1925. My proud grandfather had this photograph taken in a Wood Street film studio. (P.L.)

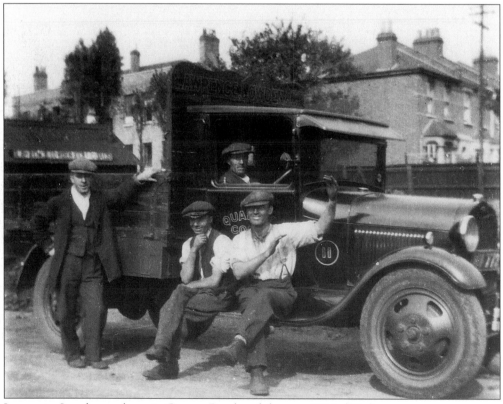

Lawrence, Lowden coalmen in Queens Road coal depot c. 1935. (P.L.)

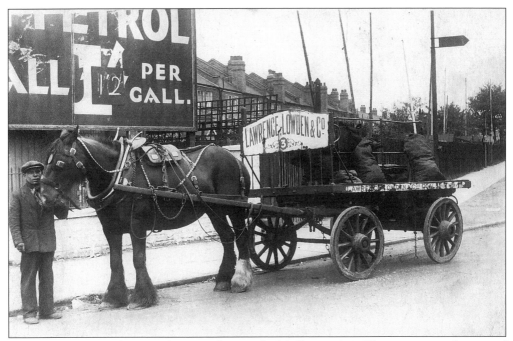

Lawrence, Lowden's horse and cart at the Crooked Billet c. 1940. The increase in the cost of petrol and rationing at the beginning of the war meant that horses came back into use again. (P.L.)

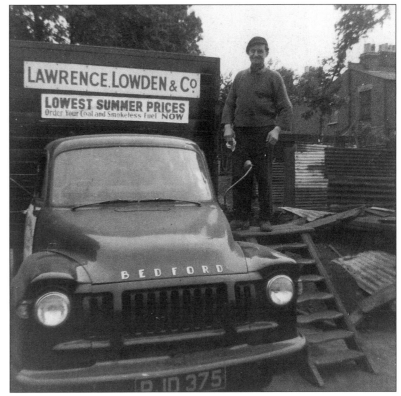

Queens Road Coal Depot, 1955. My father poses beside his latest, and last, vehicle. (P.L.)

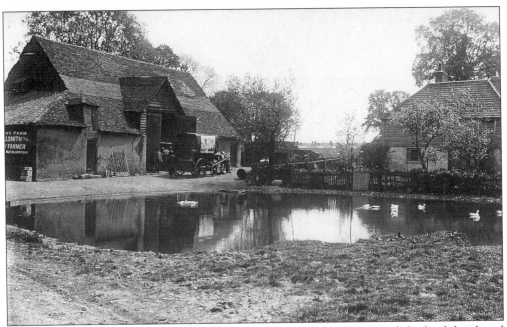

Two views of Moon's Farm in Billet Road. It was demolished in 1927 and the land developed for housing.

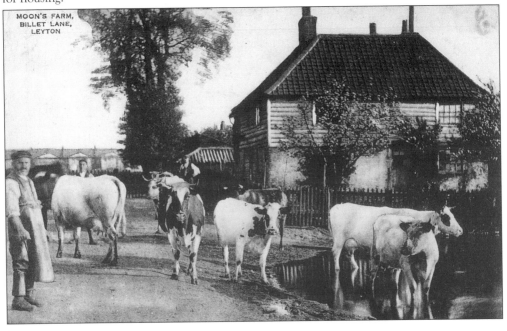

WALTHAMSTOW.

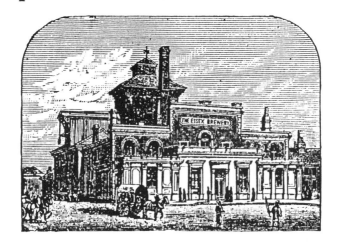

COLLIER BROTHERS,

ESSEX BREWERY,

WALTHAMSTOW.

FINEST

ALES,

PORTER,

AND **STOUT,**

THE AMBER ALE

TRADE MARK.

OF GUARANTEED PURITY.

IN 4½, 9, AND 18 GALLON CASKS.

PRICE LISTS ON APPLICATION.

PROMPT DELIVERIES TO ALL PARTS OF LONDON AND SUBURBS DAILY.

An advertisement for the Essex Brewery in St James Street in 1892. It was demolished in the 1970s.

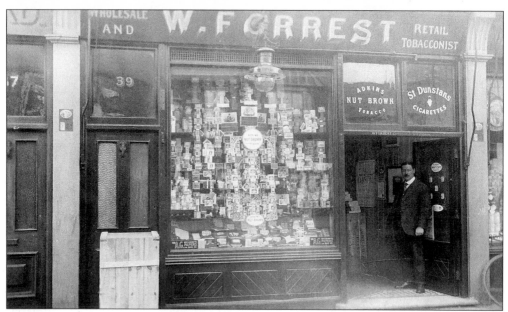

A window full of cigarettes and tobacco at the premises of W. Forrest, 39 Palmerston Road.

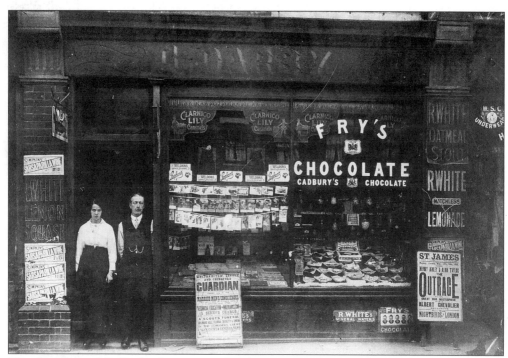

The shop-front of G. Darby, Stationer and Tobacconist at 138 Gosport Road in 1916.

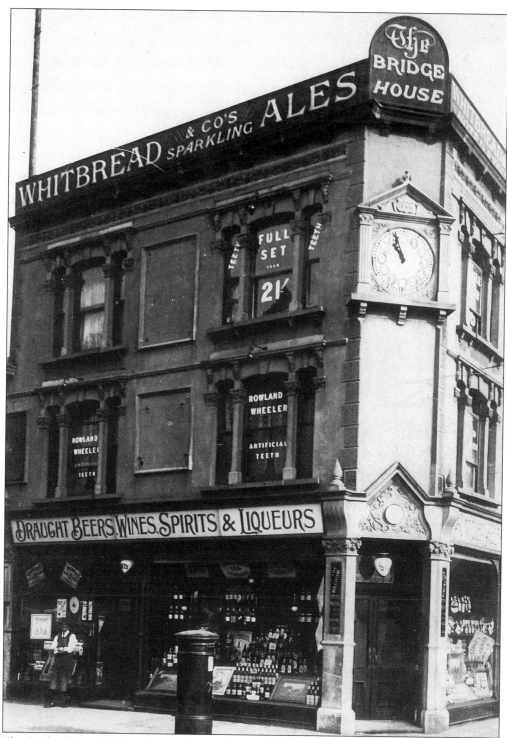

The Bridge House built in 1902 on the corner of Hoe Street and St Mary Road opposite The Tower Hotel c. 1906. The upstairs premises of Rowland Wheeler offer a full set of artificial teeth for 21s (£1.05).

A 1916 advertisement for the latest fashions from C.R. Bridgland at 151-153 Hoe Street. A paletot was a loose cloak.

Four
Buildings

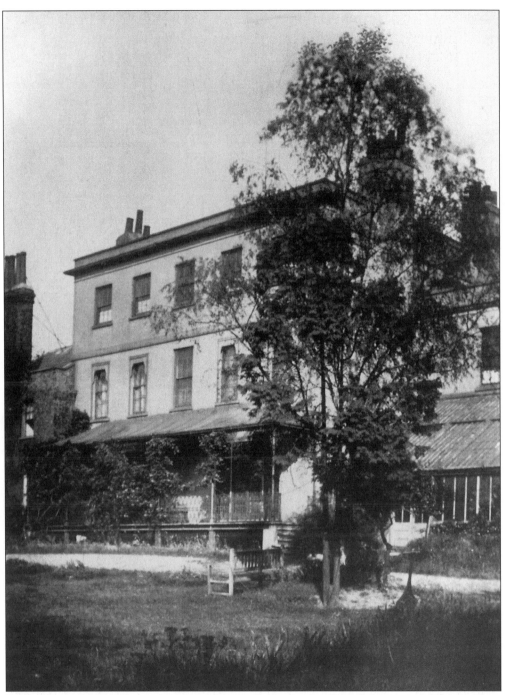

Berthons was a late eighteenth-century house which stood in Wood Street near Whipps Cross and was the residence of the Berthon family. In 1899 it was used as a hospital for Jewish incurables. A terrace of houses now stands on the site.

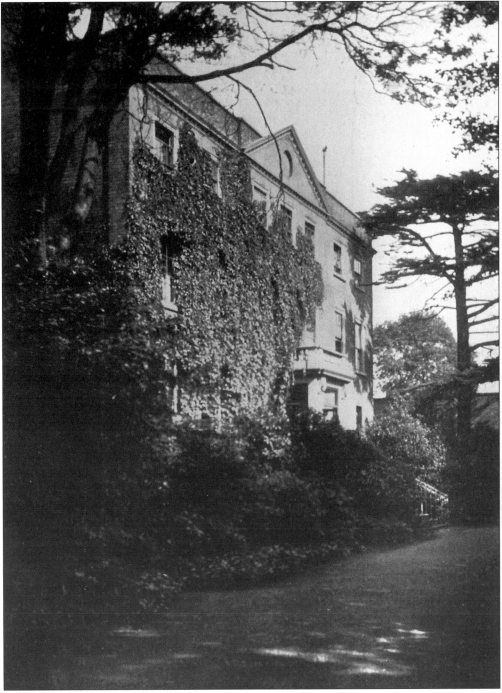

The Clock House in Wood Street was built in the late eighteenth century by a Dutch merchant. It still stands and is now divided into flats.

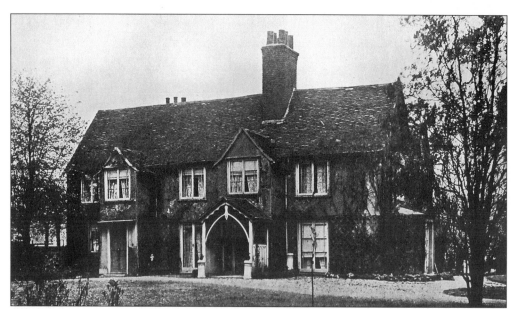

Salisbury Hall c. 1920. 'A commodious farmhouse with seven bedrooms' that stood opposite the Walthamstow greyhound stadium. Originally it was the main house of the medieval manor of Salisbury Hall that stretched from Billet Road to Chingford and from Folly Lane to Chingford Road. It was demolished in 1952.

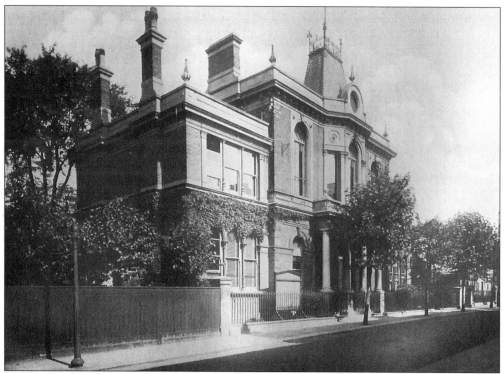

The old Town Hall in Orford Road. It was built as a public hall in 1866 and was used as the Town Hall from 1876 until 1941. It formed part of Connaught Hospital from 1959 until 1977, and has recently been restored.

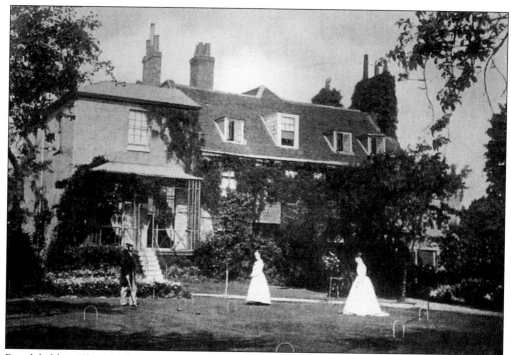

Brookfield in Shernhall Street was an eighteenth-century house and was the residence of the Collard family. The house was demolished at the turn of the century and the present Brookfield Road covers the site of the property.

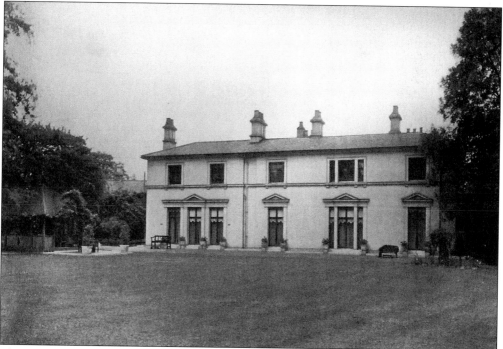

The Limes was also an eighteenth-century house in Shernhall Street.

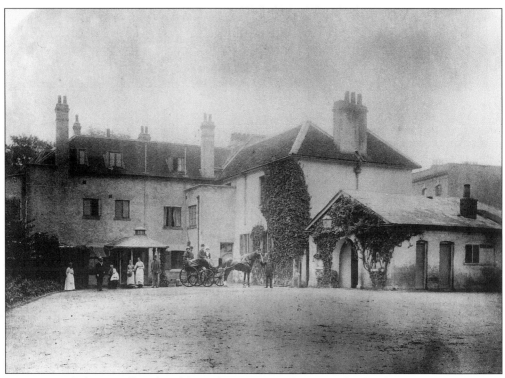

Two views of Shern Hall. It dated from the seventeenth century but by the nineteenth century had been much altered. Cardinal Wiseman lived at the house for a few years after 1849. The house was demolished in 1896.

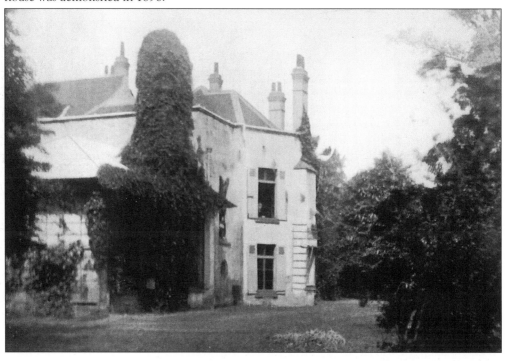

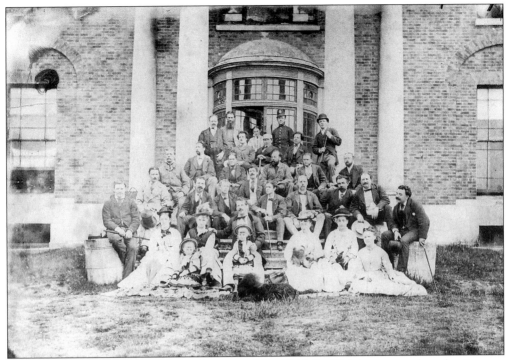

A Victorian group pose formally on the steps of Cook's Folly. This house stood on the site now occupied by Bellevue Road and surrounding roads.

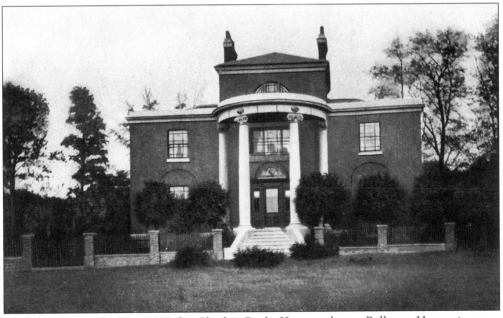

Cook's Folly was built c. 1803 for Charles Cook. Known also as Bellevue House, it was a Regency villa with a semi-circular Ionic portico. The building survived until 1937.

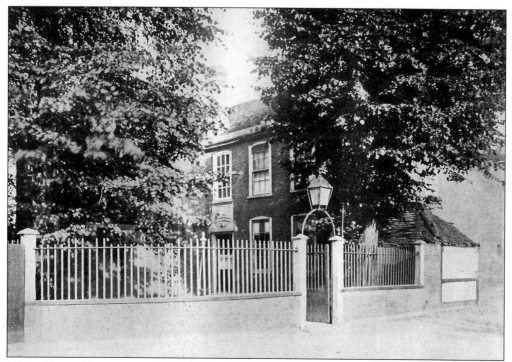

Vestry House Museum, originally the Parish Workhouse, was built in 1730-1, with extensions in 1756 and 1779. Paupers were moved out in 1840 and part of the building was used a police station until 1870. The site had several other uses until it became a museum in 1931.

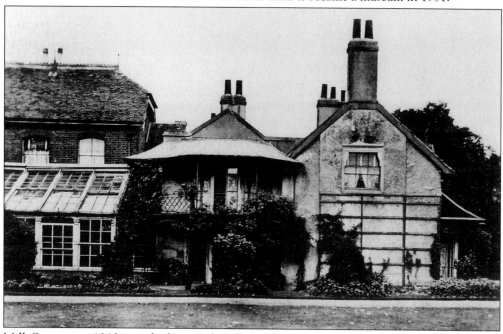

Mill Cottage, c. 1910, stood where Oak Hill Gardens is today. Originally the Walthamstow windmill stood alongside it at the top of Oak Hill, just to the north of Mill Plain. Edward Forster, the naturalist, lived there in the 1830s.

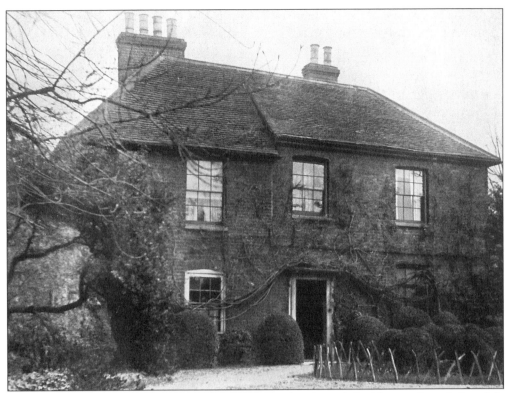

Low Hall was a seventeenth-century, two-storey, timber-framed, building with a tiled roof. It was destroyed by a flying bomb in 1944.

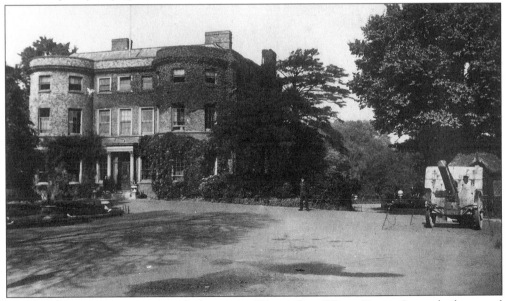

Lloyd Park Mansion was previously known as Winns then Water House. It was built around 1750. In 1898 the family of Edward Lloyd gave the house to the council, subject to the council buying nine acres of land adjoining the property. Lloyd Park was opened in 1900. The most famous resident of Water House was William Morris.

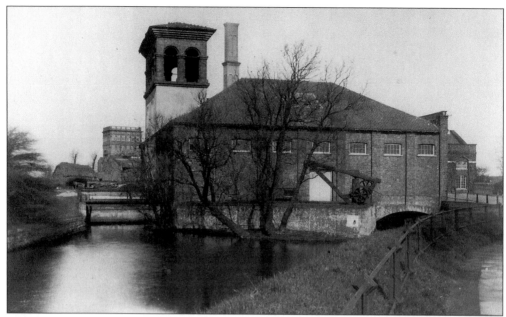

The Copper Mill c. 1900. There may have been a mill on this site since the eleventh century. There was a paper mill in the seventeenth century and an oil mill in the eighteenth century. The present building dates from around 1800 and was taken over by the British Copper Company in 1808. In 1860 it was bought by the East London Waterworks for use as a pumping station.

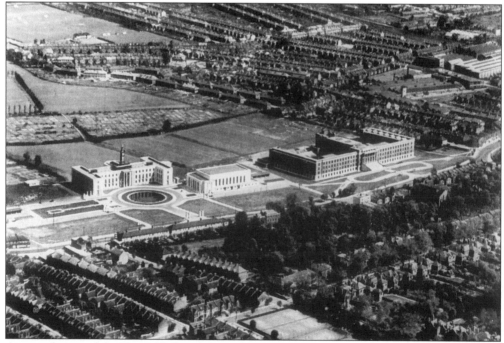

An aerial view of the Town Hall and Assembly Hall in Forest Road. They were built in 1941 and 1943 respectively, on the site of Chestnuts Farm. The large building to the right is the South-West Essex Technical College opened in 1938.

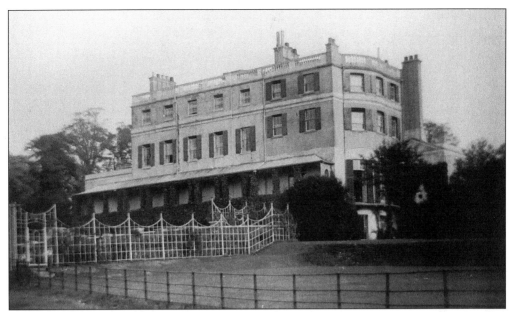

Highams c. 1900. A view of the rear of the building which is now the Woodford County High School for Girls. It was built c. 1770.

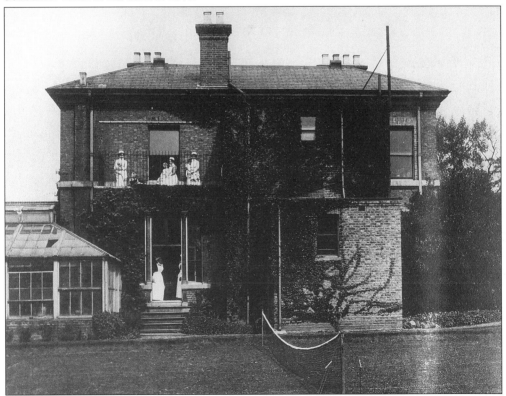

Walthamstow Cottage Hospital, 1909. The building was originally called Holmcroft in Orford Road and was bequeathed to Walthamstow in 1894. The hospital grew on the site and was named Connaught Hospital in 1928.

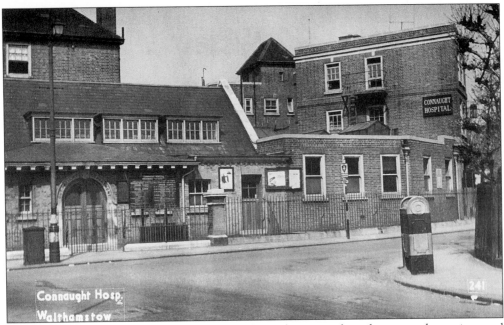

A side view of Connaught Hospital from Beulah Road. It was enlarged on several occasions and was closed c. 1980. Houses now occupy the site.

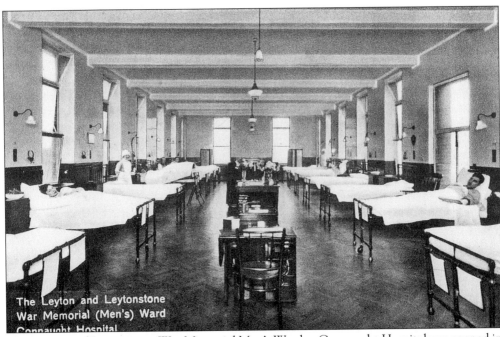

The Leyton and Leytonstone War Memorial Men's Ward at Connaught Hospital was opened in 1927.

Five

Transport

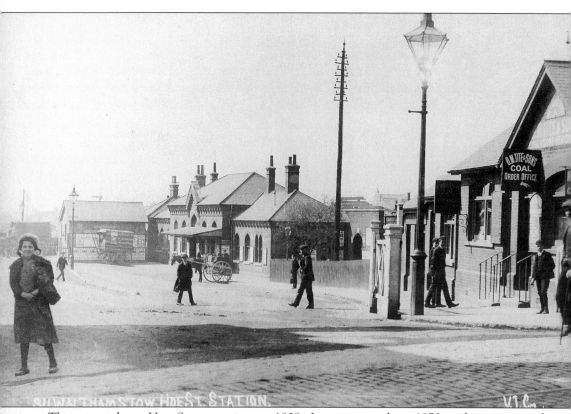

The approach to Hoe Street station c. 1908. It was opened in 1870 and was renamed Walthamstow Central in 1968. The building on the right is the office of B.M. Tite, coal merchants (see next page).

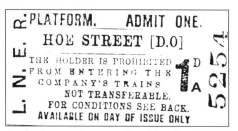

A platform ticket issued at Hoe Street station.

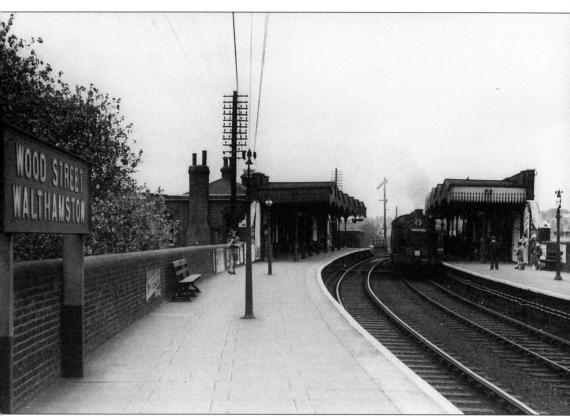

Wood Street station in the 1930s. A train for Chingford is arriving. The station was opened in November 1873 when the line was extended from Shernhall Street to Chingford.

ECONOMICAL COAL

ONE LUMP OF

B. M. TITE & SONS' "Crown Cookers"

Put on the Fire in an open grate will last **For Hours** if left untouched. ^{Reg}

Local Order Offices :—

HOE STREET and ST. JAMES' STREET RAILWAY STATIONS.

This advertisement for B.M. Tite's Economical Coal in 1916 would today probably contravene the Trade Descriptions Act!

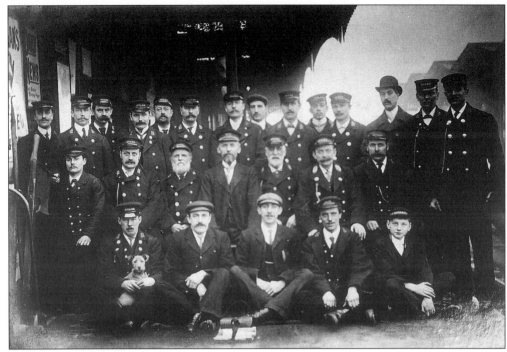

A group of Great Eastern Railway workmen at Wood Street station in 1907.

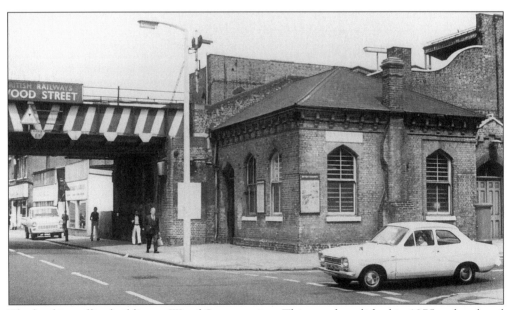

The booking office building at Wood Street station. This was demolished in 1975 and replaced by a glass and steel structure.

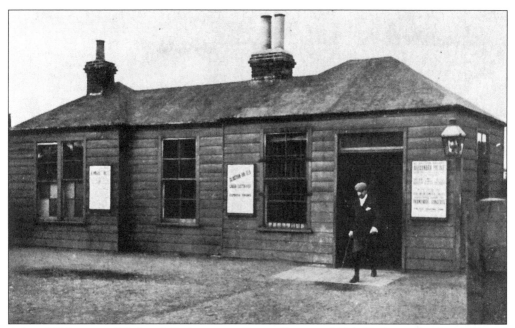

A late 1890s view of Higham's Park station. Originally named Hale End, it opened in 1873 and was renamed in 1894.

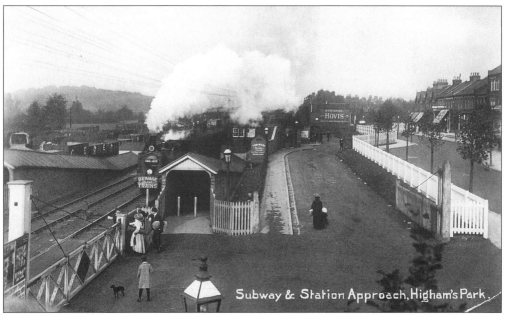

A train for London leaves Higham's Park station c. 1910. Note the foot subway under the railway lines which was opened in 1909.

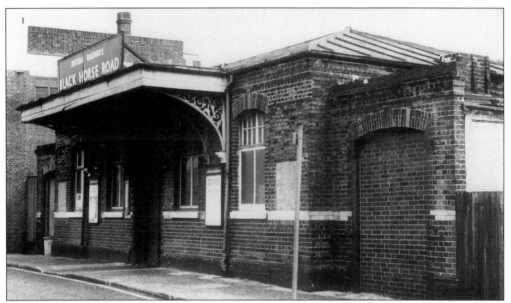

The booking office of the old Black Horse Road station. This entrance was closed in December 1981 when the station platforms were resited to the other side of the road bridge to allow an interchange with the Victoria Line of London Underground.

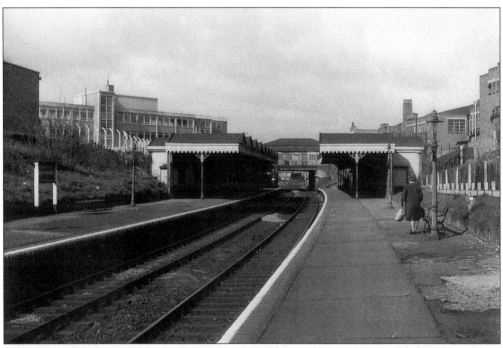

Black Horse Road station, looking west in 1965. The wooden station buildings and awnings were removed in the 1970s. The present station is situated the other side of the bridge in the distance.

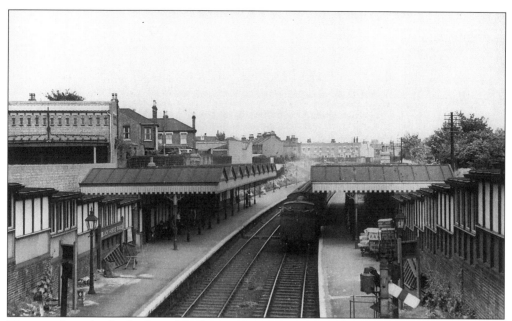

The view from the footbridge at Black Horse Road station as a train from Barking arrives in the 1930s.

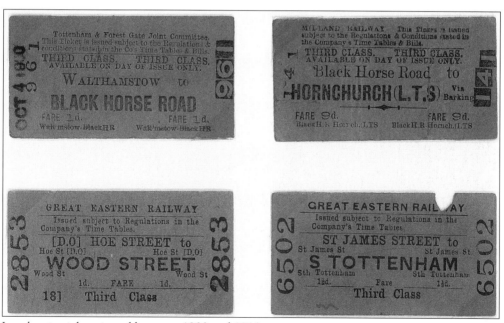

Local train tickets issued between 1900 and 1910.

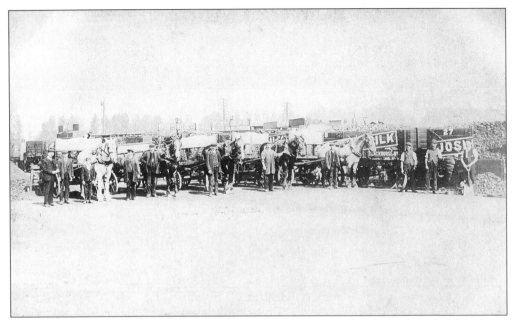

Black Horse Road Goods Depot with five horse-drawn wagons belonging to Joseph Silk waiting to be loaded with coal from railway wagons also owned by Joseph Silk. The goods depot closed in 1964.

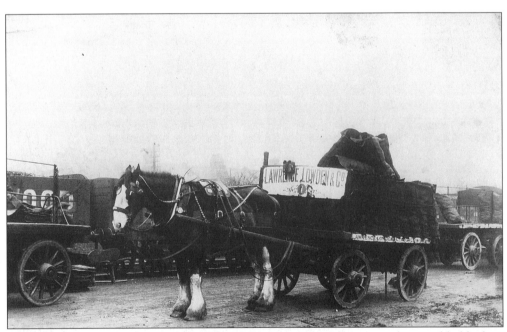

Lawrence, Lowden coal cart in Queens Road depot in 1926. There was a large stable block to rent by the different coal firms which was still used until the late 1950s. Queens Road Goods and Coal Depot closed in May 1968 and houses now occupy the site. (P.L.)

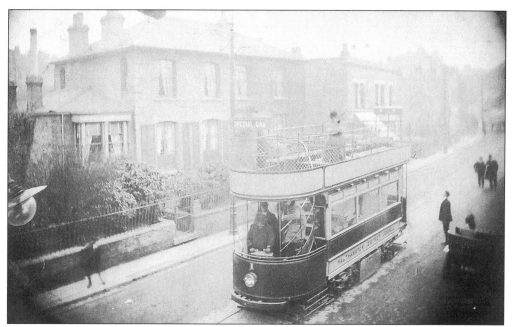

Electric tramcar No. 1 on a trial run about three weeks before the official opening. Passers-by look at the new-fangled vehicle with bowler-hatted officials on board.

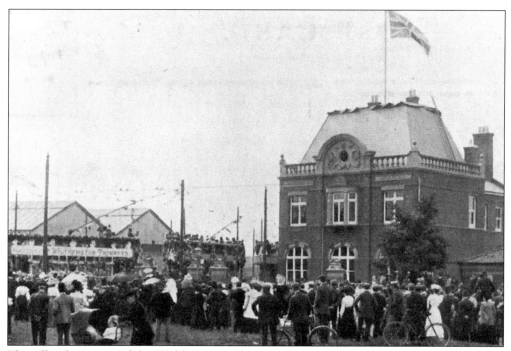

The official opening of the Walthamstow Electric Tramways took place on 3 June 1905, and here the first trams leave the depot surrounded by crowds of onlookers.

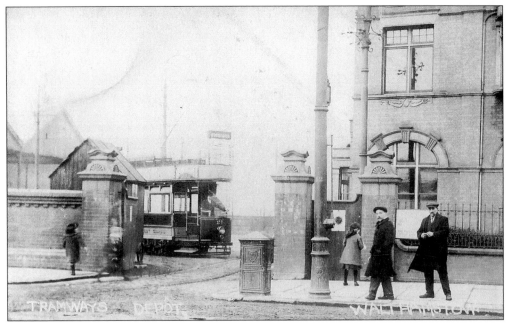

Tramcar No. 21 about to leave the depot for a journey to Woodford.

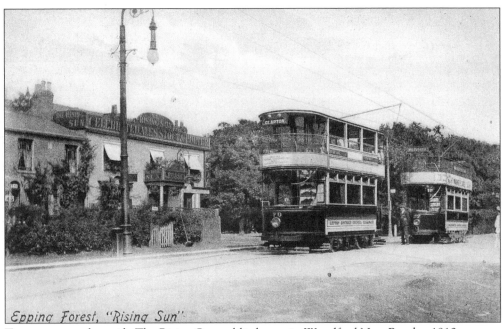

Two trams stand outside The Rising Sun public house in Woodford New Road c. 1912.

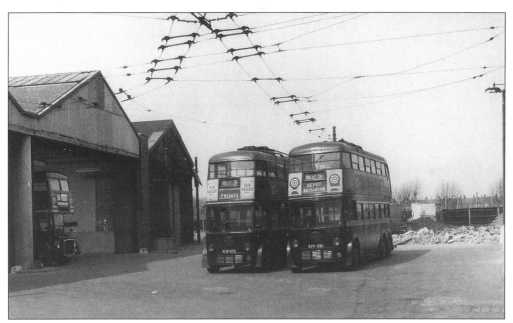

When the trams were withdrawn, Walthamstow depot was converted to a trolley-bus garage. Here, two trolley-buses are shown near the end of their service. Note the Routemaster bus on the left.

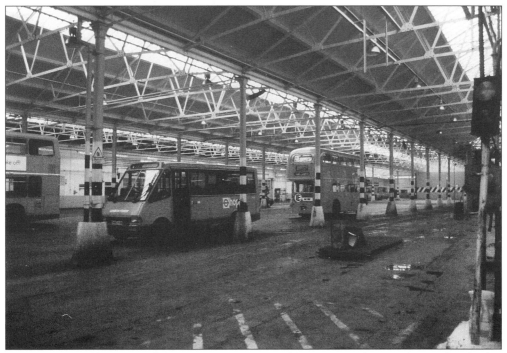

After the last trolley-buses had left, the garage was used by buses until 1991 when it closed. This view shows the interior of the garage a few days before closure. It was later pulled down and houses were built on the site.

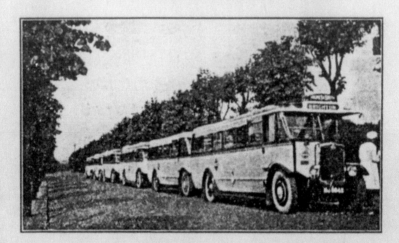
Front of a handbill advertising Black & White Pullman Coaches services and tours for the summer of 1935. Day trips to Portsmouth and Southsea cost 7s. 6d. (37½p); Brighton 5s. 6d. (27½p); Clacton 6s. 6d (32½p). A trip to Epsom for Derby Day was 5s (25p).

Six

The Walthamstow
Tram Chase 1909

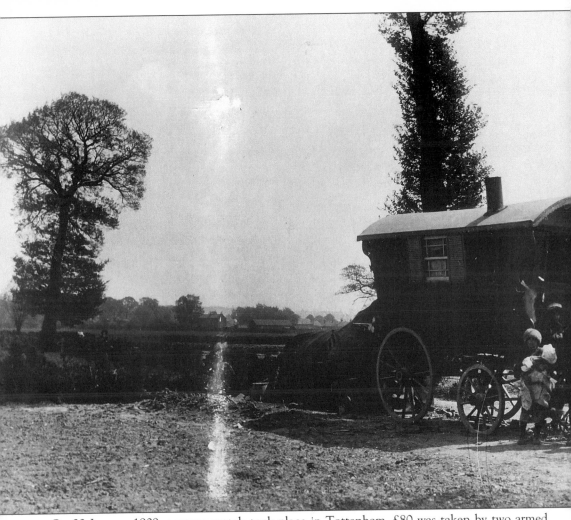

On 23 January 1909, a wages snatch took place in Tottenham. £80 was taken by two armed extremists, Jacob and Hefeld, who were from the Russian state of Latvia. They were part of a revolutionary cell based in Tottenham, one of many such cells formed by anarchists throughout the poorer parts of Edwardian London. As they were chased by police and the public across Tottenham Marsh to the River Lea and Higham Hill, they left a trail of two dead, a policeman and a ten-year-old boy, and fifteen wounded. The villains then ran through this gypsy encampment near Salisbury Hall Farm on their way to take shelter in the farmyard having run all the way from Tottenham High Road.

Jacob and Hefeld hid by this haystack in Salisbury Hall Farm before breaking cover and running out into Chingford Road and hijacking a tram on its way to Bell Corner.

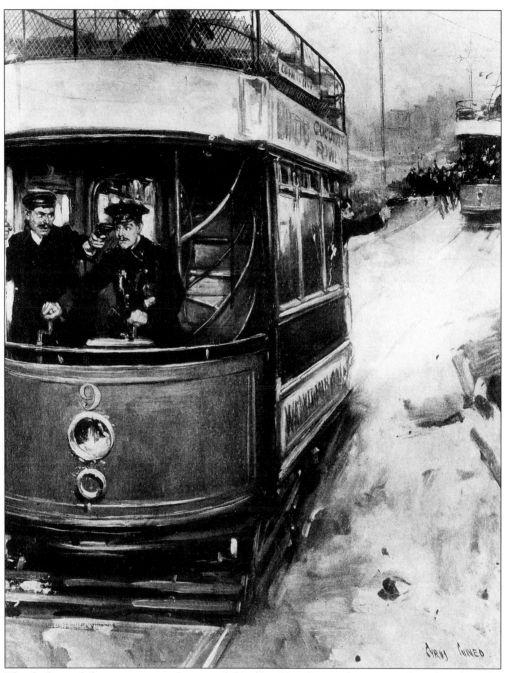

The frightened driver got onto the top of the tram but the conductor was forced to drive by Jacob who held a gun to his head. A second tram was commandeered by police, and a Keystone Cops-style chase ensued while Hefeld fired at the police as they pursued them. They then stole a pony and trap at gunpoint and raced along Forest Road, Fulbourne Road, Wadham Road and into Winchester Road followed by police who had now commandeered cars.

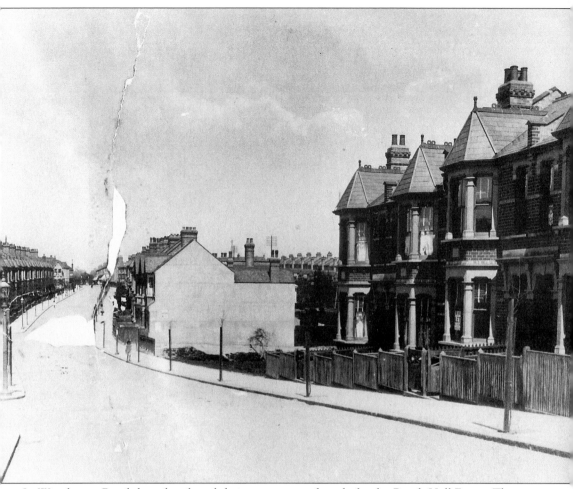

In Winchester Road they abandoned their transport and made for the Beech Hall Estate. They ran between the gap in the houses where the River Ching flows.

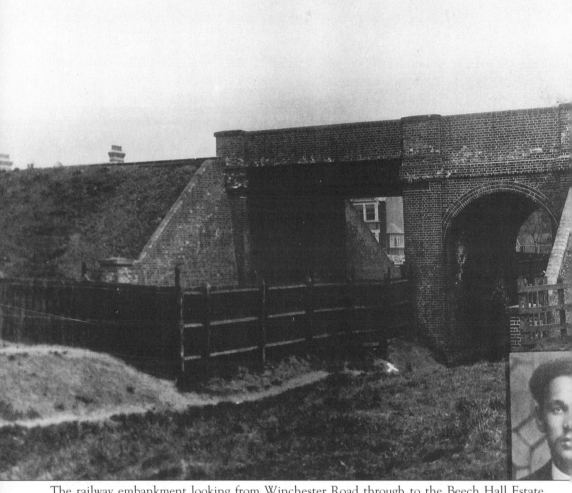

The railway embankment looking from Winchester Road through to the Beech Hall Estate. Here, Jacob was able to climb over the fence but 'Paul Hefeld' (pictured) was too exhausted so he shot himself rather than be captured. Jacob ran across Hale End Road, behind The Royal Oak pub and in the back door of a small cottage which stood a few yards away in Oak Hill.

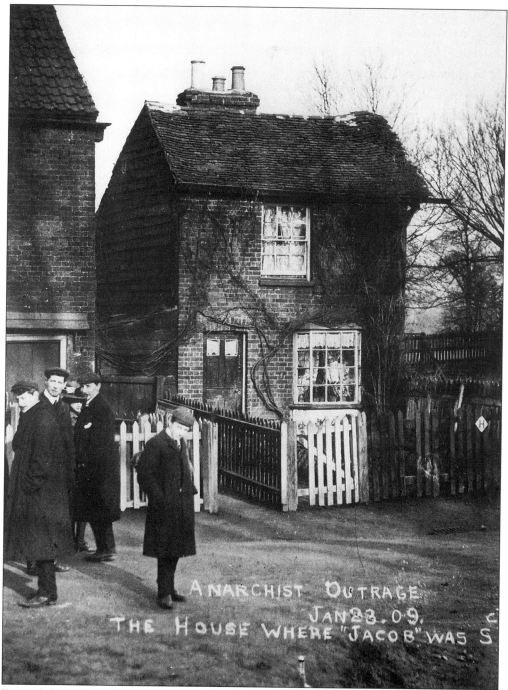

ANARCHIST OUTRAGE
JAN 23. 09.
THE HOUSE WHERE "JACOB" WAS S

For a while two little boys were trapped in the cottage with Jacob but they were rescued. There was a final shoot-out with Jacob committing suicide when he was almost out of bullets. The money was never recovered.

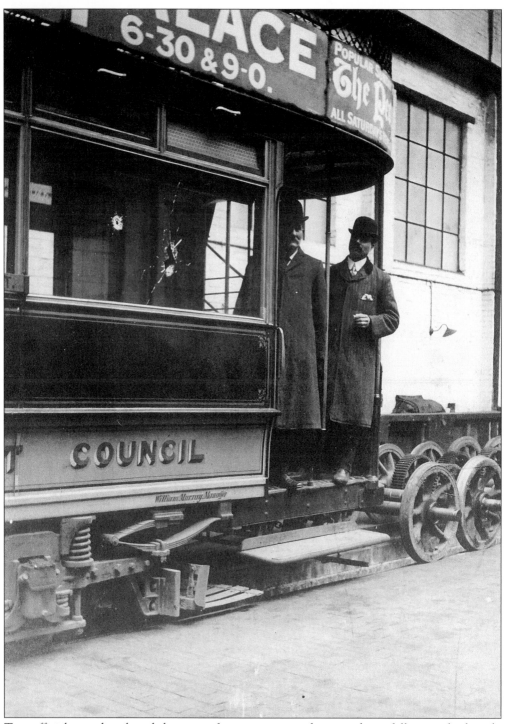

Two officials stand on board the tram after its return to the tram depot following the hijack. The bullet holes in the window are clearly visible.

Seven
Churches

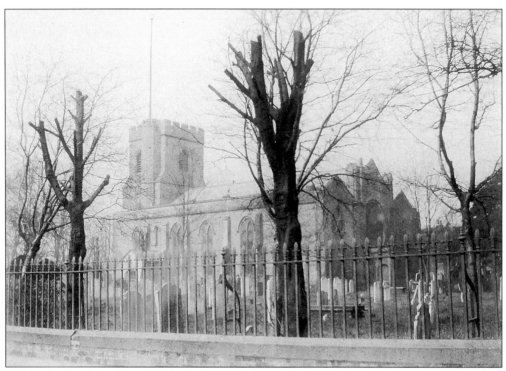

St Mary's church has been on this site since the twelfth century. Although parts of the fabric are late medieval there were major alterations in the sixteenth, eighteenth and nineteenth centuries. The south aisle was bomb-damaged in 1940.

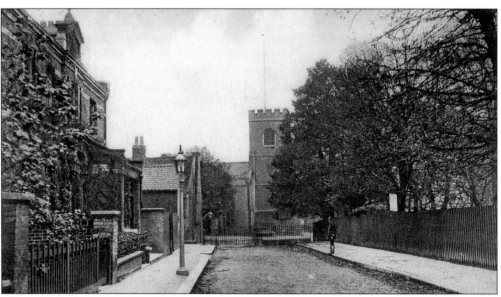

The entrance into St Mary's churchyard from the north, c. 1910.

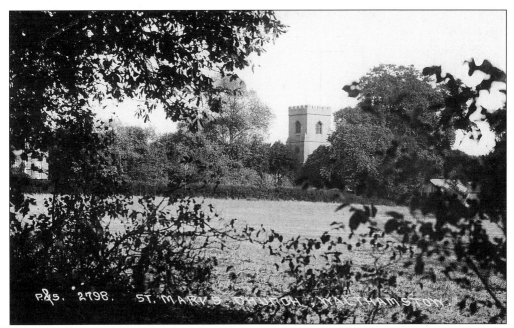

An unusual view of St Mary's church c. 1910 across 'Glebe Field'. The old vicarage can just be seen on the left.

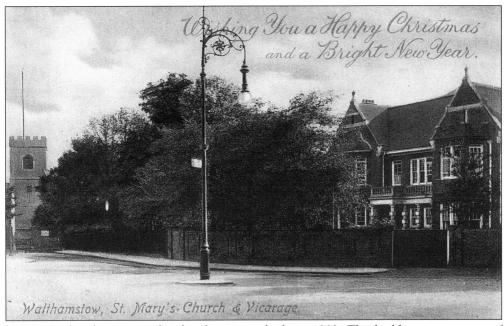

St Mary's church vicarage shortly after it was built in 1903. The building is now part of Walthamstow School for Girls, and the new vicarage is situated on the opposite side of the road.

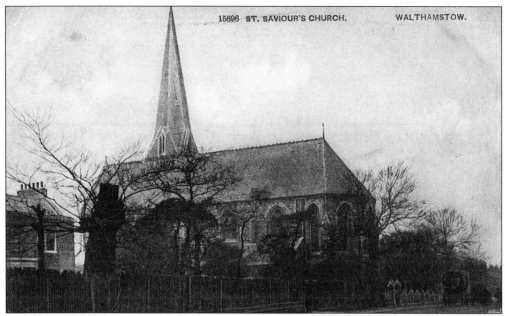

St Saviour's church in Markhouse Road c. 1905. It was built in 1874.

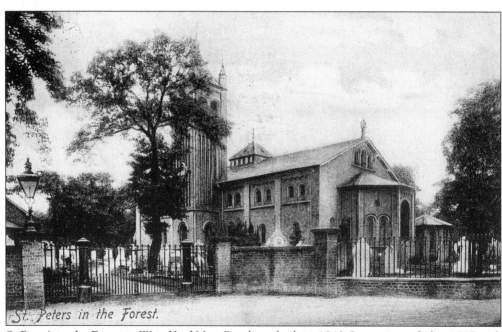

St Peter's in the Forest in Woodford New Road was built in 1840. It was extended in 1887 and, after damage caused by a rocket in 1945, it was repaired by 1951. Further alterations were completed in 1958.

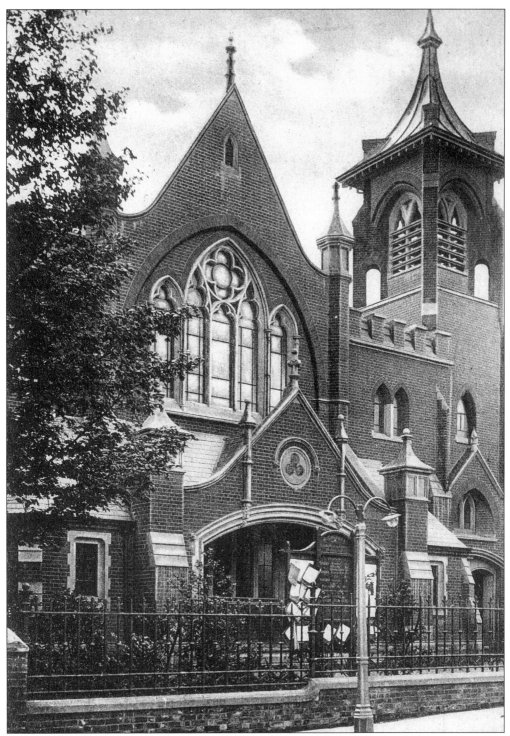

St Columba Presbyterian church in Prospect Hill c. 1908. It was built in 1906 and restored in the 1950s after war damage. It was demolished in 1970 and a block of flats now stands on the site.

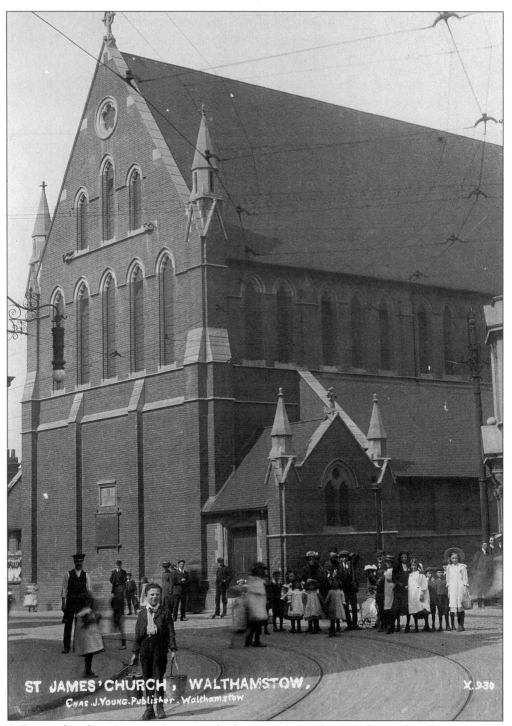

ST JAMES' CHURCH, WALTHAMSTOW.

Chas. J. Young. Publisher. Walthamstow

X.930

St James' church in St James Street was built in 1902-3 on the site of an earlier church built in 1842. The east window and many of the bricks of the original church were used in its construction. The church was closed in 1960 and demolished two years later. St James Health Centre now stands on the site.

The Methodist church in Church Hill by the corner of Hoe Street. It was built in 1898 and was destroyed by bombing in 1944. An office block today stands on the site.

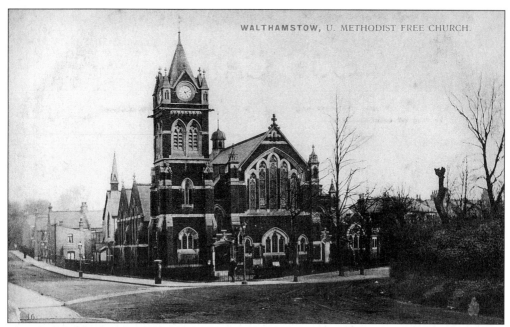

Shernhall Methodist church was opened in 1901. It was built in red brick with stone dressings. It was demolished in 1976 and replaced by a new church which opened on the same site in July 1977.

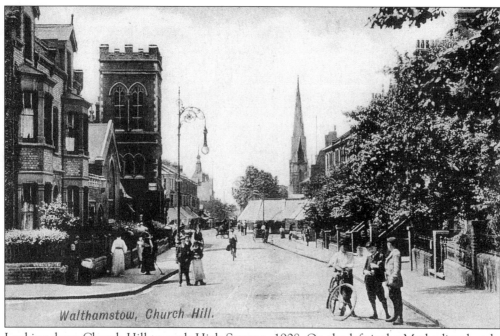

Walthamstow, Church Hill.

Looking down Church Hill towards High Street c. 1908. On the left is the Methodist church, and in the distance can be seen the spire of Marsh Street Congregational church.

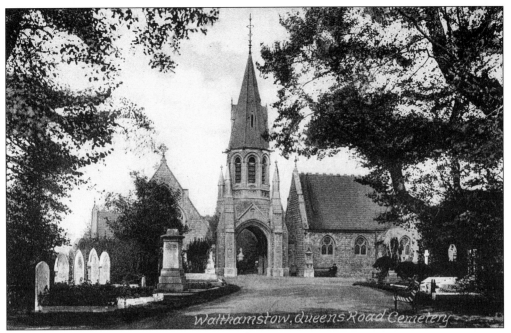

Queens Road cemetery c. 1905. It was opened in 1872.

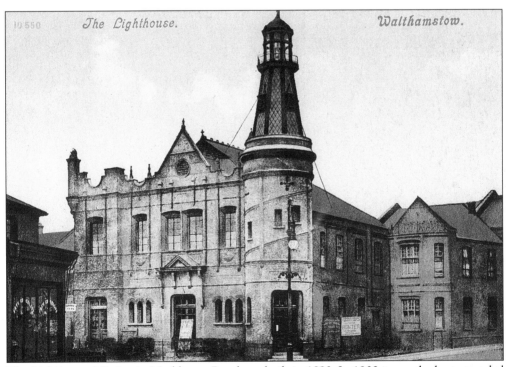

The Lighthouse Mission in Markhouse Road was built in 1893. In 1903 it was the best attended nonconformist church in Walthamstow.

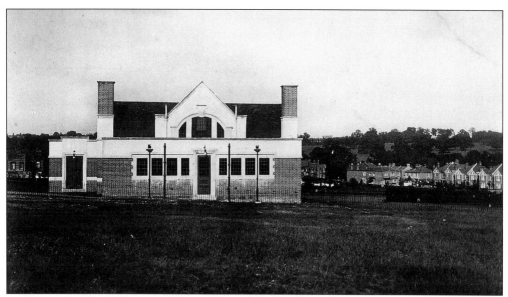

Higham's Park Methodist church was opened in 1909. This photograph was taken shortly after it was built.

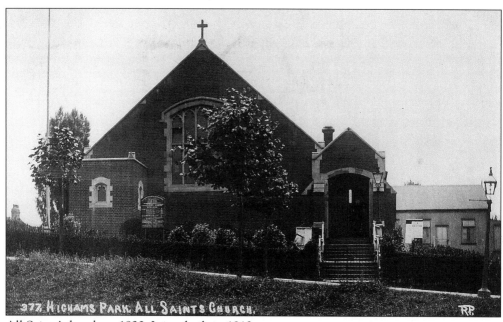

377. HIGHAMS PARK. ALL SAINTS CHURCH.

All Saints' church, c. 1920. It was built in 1912.

Eight
Schools

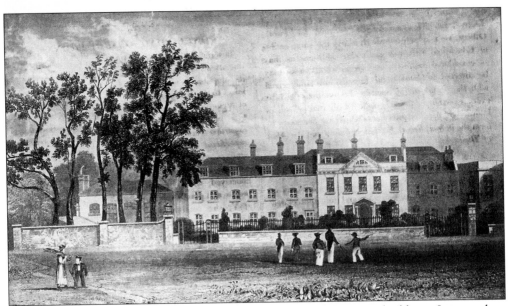

Forest School was founded in 1834 and consisted of several Georgian buildings. It opened on 1st October 1834 with 25 boys and 3 masters.

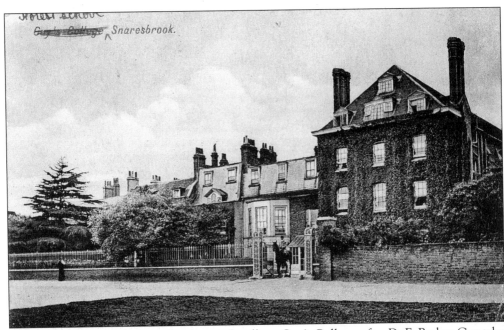

Forest School c. 1905. It was often known locally as Guy's College, after Dr F. Barlow Guy who started to teach at the school in 1852. In 1856 he became sole proprietor and headmaster until his retirement in 1887. He had twenty children, and nine of his ten sons attended the school.

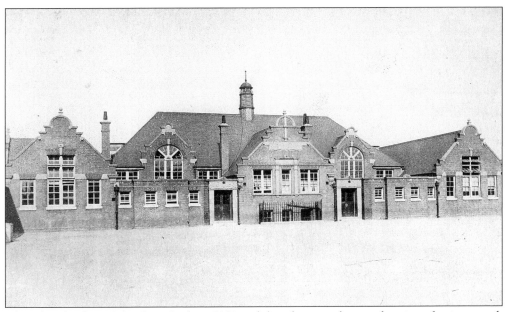

Chapel End Infants School was built in 1903 and this photograph was taken just after it opened.

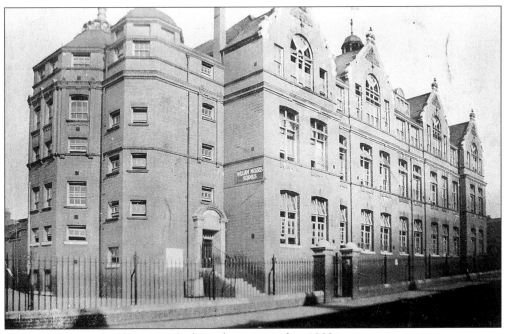

William Morris School in Gainsford Road was opened in 1902.

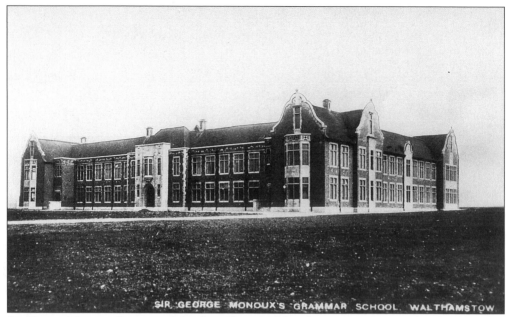

Sir George Monoux Grammar School in Chingford Road was opened in 1927 and enlarged in 1932 and 1961. It was built on the site of Chestnuts Farm.

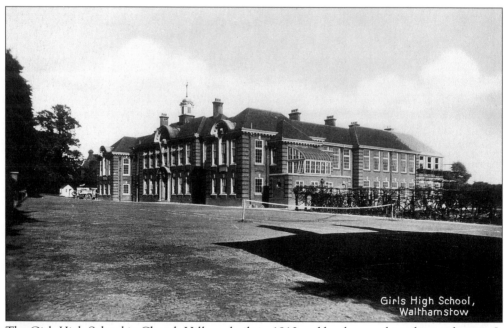

The Girls High School in Church Hill was built in 1913 and has been enlarged several times. It was built on the old vicarage glebe.

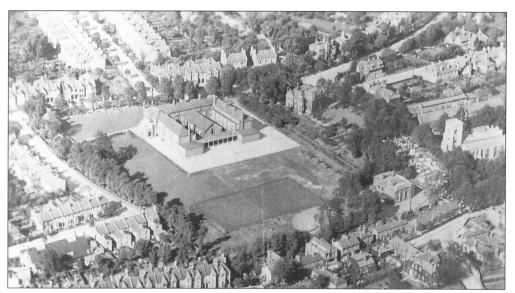

An aerial view of the Girls High School with St Mary's church to the right.

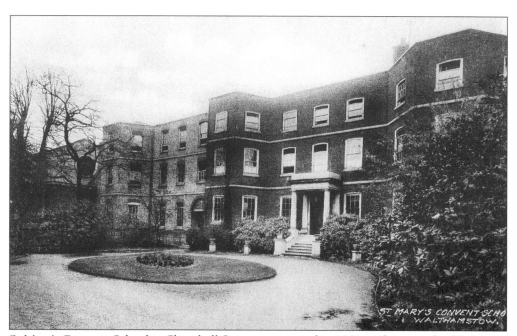

St Mary's Convent School in Shernhall Street was opened in 1931 in the grounds of St Mary's Orphanage. The building is eighteenth century and was originally called Walthamstow House and was owned by the Wigram family from 1782.

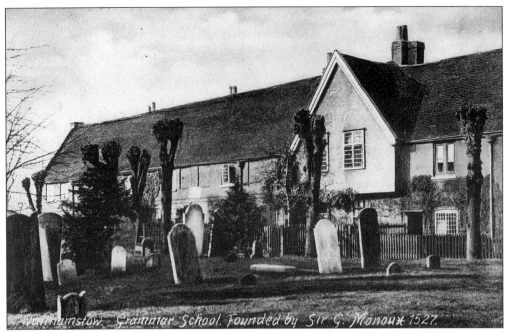

Monoux Almshouses in St Mary's churchyard c. 1905. Founded in 1527, the building was used as a school for over 350 years. After being bombed in 1940 it was rebuilt in 1955.

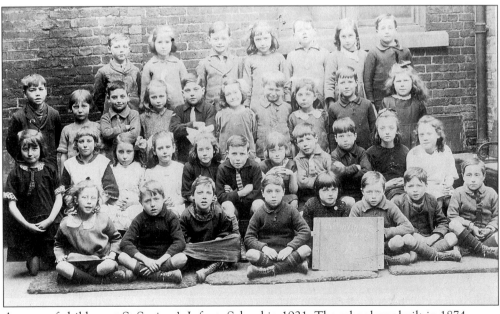

A group of children at St Saviour's Infants School in 1921. The school was built in 1874.

Nine

Public Houses

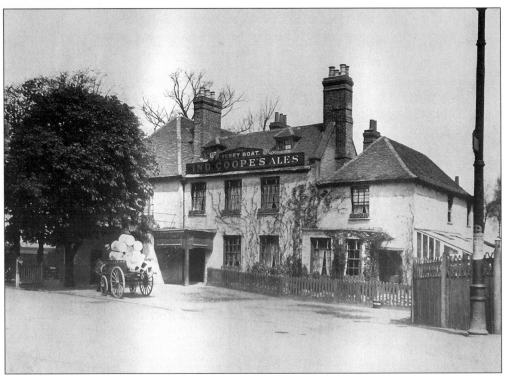

The Ferry Boat Inn at the turn of the century. The original inn is thought to date from the early eighteenth century.

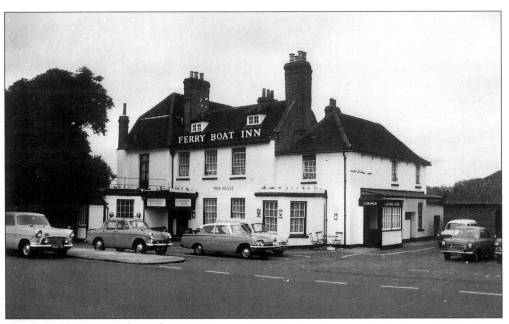

The Ferry Boat Inn in the early 1960s.

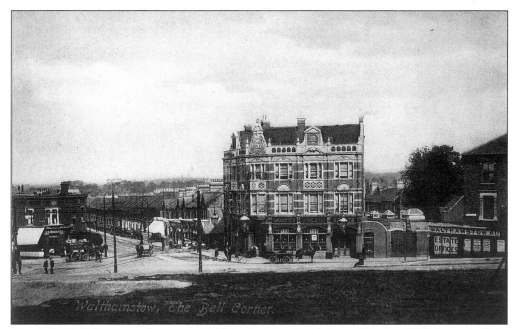

The Bell public house at the corner of Chingford Road and Forest Road c. 1907. It was built in 1900. The empty space in the foreground is the site of the Empire Cinema, built in 1913. It was latterly named the Cameo and is now a snooker hall.

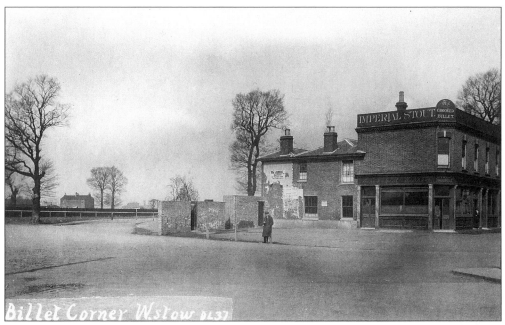

The Crooked Billet c. 1920. There has been a public house on this site since the eighteenth century. The building shown in this picture was replaced in the 1930s and that was demolished in the 1980s.

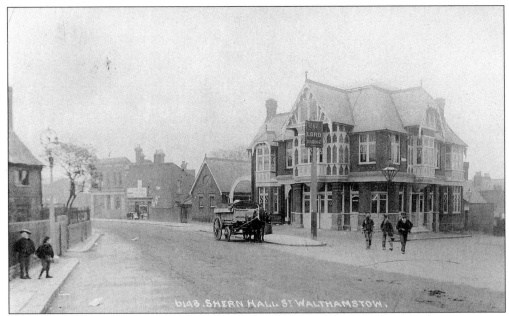

The Lord Brooke public house in Shernhall Street c. 1907.

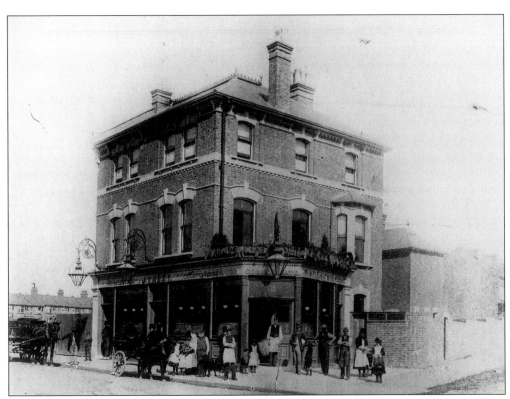

The Common Gate public house in Markhouse Road on the corner of Queens Road in 1888. The name recalls the gate leading onto Markhouse Common.

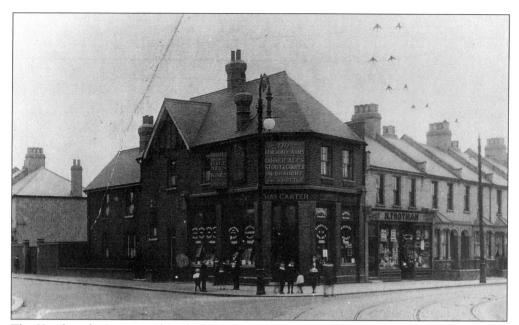

The Kenilworth Arms in Chingford Road on the corner of Farnon Avenue in 1909. It was destroyed in the Second World War.

A business card for the Higham Hill Tavern in the late 1950s. The business was run by my mother's brother. The Rustons came from Gloucester Road. (P.L.)

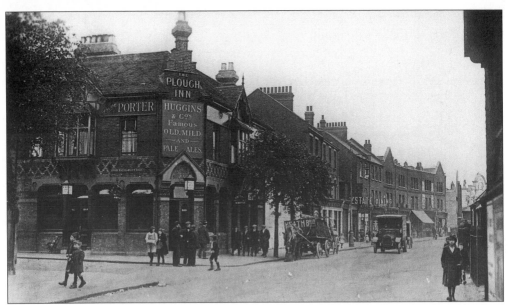

The Plough Inn on the corner of Wood Street and Upper Walthamstow Road was built in 1875.

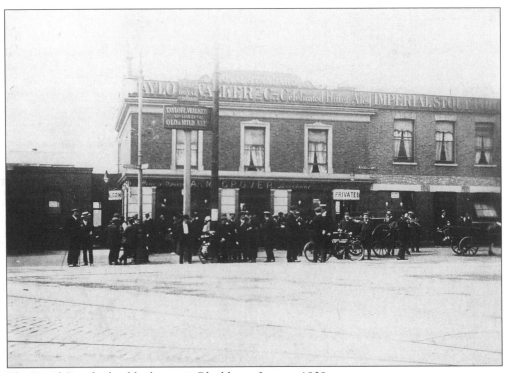

The Royal Standard public house in Blackhorse Lane c. 1909.